Mo Willems is a gifted young artist with energy and
zest for his work and his family. His talents and creative inspiration are
expressed in his books as well as in his sketches and his sculptures, one of
which—a bright red elephant—luckily for us now graces the grounds of
the Eric Carle Museum of Picture Book Art.

Aside from his other artistic expressions, Mo Willems is a master of the
doodle, sketch, cartoon, and scribble, and I am delighted to be writing an
introduction for this collection, because I am also a sketcher and doodler
and a fan of the art that illustrators often create "on the side" and "just for
fun," as they say, but which sometimes is their best work, though it may
not necessarily appear in a book or be framed and hung on the wall.

When I was a boy, I used to sit on my father's lap while he read the funny
pages in the Sunday newspaper to me. These Sunday mornings gave me a
sense of joy and of art, as well as lasting connection with my father—what
we now know is the life-changing value of being read to and held as a
child. I mention this experience with my father and the Sunday funnies
because Mo's work rekindled emotions akin to those early feelings.

It has been my pleasure to know Mo, who has brought so much of his
wonderful spirit and creativity to the part of western Massachusetts
where I used to live. My wife, Bobbie, and I were fortunate enough to be
invited to dinner at the home of Mo and his wife, Cher. The highlight of
the evening was to join in their doodling fun on their chalkboard walls,
followed by more doodling on their dining table, which was covered
entirely by paper from one end to the other. We were encouraged to draw
and scribble, "to doodle over dinner," as Mo calls it. The Willemses invite
all their friends to partake in this ritual. And in this way, Mo has amassed
an interesting, beautiful, and valuable collection that should be the envy
of many a collector of this genre.

Fortunately, a sketchbook series that Mo has created over the years
for friends and family in his playful doodle style has found a home in
this book—one that will be enjoyed by readers and fans of all ages. It
will be an inspiration to doodlers and illustrators, secret sketchers and
cartoonists—and to those in the making.

Eric Carle

MO WILLEMS ROCKS!

DON'T PIGEONHOLE ME !

You are always at the mercy of your audience. A child experimenting with cursing quickly discovers that the same "dammit" that elicited nervous giggles at recess garners quite a different reaction during Thanksgiving dinner. For that kid, the audiences' different requirements are simple, unavoidable facts. As an artist, ultimately, I find it's better to acknowledge my audience's power and get on with it.

Fortunately, I like audiences. Over my lifetime of trying to make people laugh through my work on stage, television, radio, or the page, I have evolved a credo:

"Always think *of* my audience, but never think *for* my audience."

Even so, occasionally I get this funny feeling . . . I yearn to make something that is purely mine, free from any restrictions, without regard for those who will eventually see it. This feeling is an affliction every "creative type" suffers through to a greater or lesser degree. In small doses, it's called having "an artistic vision"; in larger doses, it's known as having "zero commercial potential."

Well, the book in your hands is the culmination of two decades of acting on those yearnings. The twenty volumes of *The Mo Willems Sketchbook* included here have been a calling card for clients and/or a holiday card for friends. But mostly they've been a continuing experiment, the illustrated version of a series of Thanksgiving dinners where I get to say "dammit" if I want.

Much like the stories and drawings in each year's sketchbook, the whole idea of putting out an annual collection of drawings was the result of a series of fortuitous accidents. Twenty years ago, I was a starving artist, and like most struggling arty types, I hustled for work while secretly dreaming of becoming the voice of a generation (hopefully mine). In New York City, I soon discovered a similarly minded circle of friends and acquaintances who, *completely coincidentally*, also dreamed of changing the world by becoming the voice of their generation. And they would do it through 'zines.

Yep, hand-bound mini-magazines that kept copy shops profitable in the 1990s would be our ticket to, if not immortality, perhaps a real career in print later on. Now, of course, you can create a Web page, or a blog, or a tweet, which is great. But they're not as fun as 'zines, if for no other reason than, you don't get to have a scruffy publishing party after you post a blog entry. But after every issue of a 'zine was stapled together, there was a celebration.

The 'zine that I found myself drawing and writing for, appropriately titled *Ersatz*, was run by an up-and-coming suit-clad journalist named Sam Pratt who was the real deal (on account that he was actually *paid* to write for real magazines—at least occasionally). I hung around the edges of the ersatz *Ersatz* scene submitting a few gags or cartoons, in the hope of changing the face of cartooning. Or if not that, getting invited to some of the parties.

The writers were a pretty talented bunch, and quite quickly many of them started getting real work for real magazines and newspapers. They also started to realize that parties alone are poor incentive to contribute stuff for free. So, sure enough, one fall day in 1993 Sam found himself without enough material for his December issue. As it happened, I was thinking of creating a special calling card to interest new (read: *any*) clients. I wanted it to be special in that it would look like a booklet and even more special in that I wouldn't have to pay to have them printed up.

So, I suggested we publish a whole issue of my gag cartoons. With no other options, Sam acquiesced. Soon we found ourselves cutting, sorting, and stapling the twenty-eight pages of gags into neat little 4¼" x 5½" booklets. *The Mo Willems Sketchbook* was born.

For the next few years, the sketchbooks doubled as the December issue of *Ersatz* and a promotional collection of cartoons for clients and pals. Then, when Sam decided journalism was not for him and folded his 'zine, I moved the sketchbook over to Curious Pictures, the animation production company where I created short cartoons for Nickelodeon and, later, Cartoon Network. They enjoyed printing my little books in the spirit of contractual obligation, and I enjoyed getting to have a second color on the cover.

By this time, *The Mo Willems Sketchbook* had evolved into more of an aesthetic opportunity. I could now experiment with story, characters, drawing styles, and design without any career repercussions. The work became more personal, or darker, or just plain weirder. Every single year, the sketchbook project allowed me the freedom to mess about and even fail in ways I couldn't, or wouldn't, otherwise.

Another fortuitous accident occurred when one of these sketchbooks took flight, becoming an actual book that launched my career as a children's book author and illustrator. I certainly never planned for *Don't Let the Pigeon Drive the Bus!* to change the course of my career, but I wasn't about to look a gift pigeon in the mouth.

With my entry into the world of books, the purpose of the sketchbooks seemed to have been usurped by my freedom to write what I wanted when I wanted and get it published. The constraints of television, by definition collaborative and expensive to produce, leave little room for the freedom afforded in books. Even so, as I looked back on my previous sketchbooks, I realized what I really wanted to do was to keep making these quirky little things. They were . . . fun.

So, I kept going, drawing in a looser, more improvisational manner as I went along. I set time aside from my schedule just to immerse myself in the power of simple, mindless doodling. I started playing around with wordless stories, something I was (and am) too afraid to try with my real books.

Of course, I never escaped the audience completely. I knew my friends would read these books, as now you will. But, I didn't really care, allowing myself to do exactly as I pleased. In some ways the stories and gags in this collection are a parallel world to my career in television and books, but they also became the well I found myself drawing from when it came time to create new work (at least three of my picture books can be directly traced to ideas in these sketchbooks). I am immensely grateful to have gotten the opportunity to make these booklets, lucky to have been able to keep doing them, and truly happy to have whiled away many hours drawing them when I should have been working, dammit.

Mo Willems

Mo!
OCT 0 2 2012

1. THE MO WILLEMS SKETCHBOOK I

The first sketchbook was put together using gags I'd submitted to real publications, plus a few quickly drawn to fill the volume out. The process of putting the booklet together was surprisingly exciting; it was so much cooler having these jokes stapled together than lying around in my files. After we were done assembling the copies, I would spend time just flipping through the pages with a goofy grin on my face.

Almost immediately, I found that I could mine the sketchbook for ideas. The cartoon of a guy walking by a poster of himself with the word UNWANTED above it became the starting point for *Another Bad Day for Philip Jenkins*, a short animated film I made a year or so later.

The trickiest part of the book was coming up with (or rather padding) my biography. I was an auditioning writer at *Sesame Street* at the time, but had not yet been hired, so I decided to focus mostly on the benefit stage show entitled *Tooth Aid '93* that financed the repair of a tooth I'd chipped the previous New Year's Eve.

the Mo Willems Sketchbook...

INK

AN **ersatz** ® PUBLICATION

"When I met Mo at NYU in 1987, he was already a tireless hyphenate comedy guru. He created both an improv and a sketch-comedy troupe, and he was always writing, sculpting, animating, drawing, and hatching plans. He has that rare combination of inborn talent, a specific point of view, and the discipline to make his projects happen. If you want to feel like a lazy-ass, hang out with Mo."
—David Wain, filmmaker and comedian

I. **Books**

II. Bars

"Dad, I'd like you to meet Jacques. Jacques is Cajun."

THE GRIM REAPER AT HAPPY HOUR

IV. City Life

"Hey! Betcha can't make it to the other side of the street!"

PANDORA'S BOX

"Actually, he looks a little more like his mother."

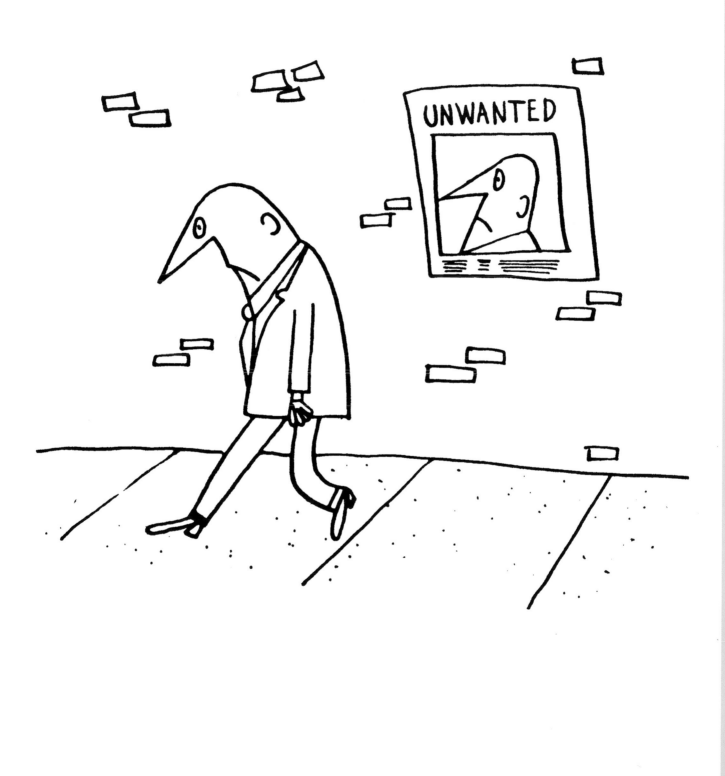

V. **Extras**

*"We were singing 'Who's Afraid of the Big Bad Wolf,'
when I suddenly realize, 'Hey, I am.'"*

NARCISSUS DISCOVERS VIDEO

TOM WAS TIRED OF JOHN CONSTANTLY FAXING HIMSELF OVER UNINVITED.

*"A study released today says
the average family has 9,246.2 children."*

2. THE MO WILLEMS SKETCHBOOK II

In college, I discovered old cartoon volumes, such as *The Cartoon Treasury* and 1950s *New Yorker* and *Punch* anthologies, at a street vendor on Astor Place, and my life changed. I was entranced by these seemingly effortless (and often wordless) cartoons that, despite coming from all over the world, had so much in common. Meant to amuse, to elicit smiles rather than guffaws of laughter, the drawings exuded a calm sophistication. Even the fancy binding of the books was impressive and sophisticated, dating from a time where cartoon collections were mainstream.

Suddenly, I knew I wanted to draw and write exactly like the stuff in those musty books.

Unfortunately, gag work had changed considerably since the 1950s. Gags were either more dialogue-heavy or relied on gross-out jokes. Gone were the days when simple wordless, amusing drawings sold (or at least I couldn't get mine sold). No biggie. With the sketchbooks, I could ignore the reality of the marketplace and put my work out there. I was also able to write gags that only I would enjoy or even get (see the man with his feet on an "Ottoman" or the boomerang table gag).

"If Saul Steinberg and William Steig had a love child, it would be
Mo Willems. And a medical miracle."
—Hilary Price, cartoonist, *Rhymes with Orange*

Furniture

1.

2.

3.

4.

5.

City Life

1.

2.

3.

4.

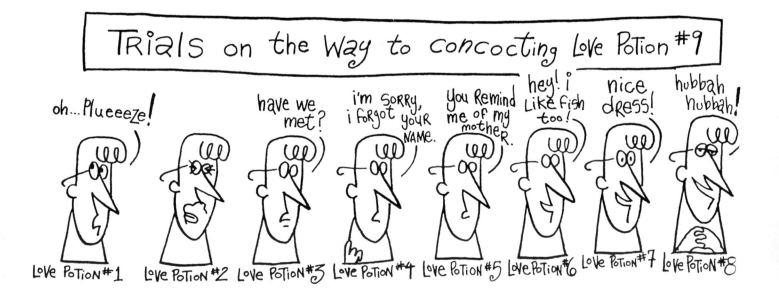

Trials on the Way to concocting Love Potion #9

oh... Plueeeze!

have we met?

i'm sorry, i forgot your name.

You Remind me of my mother.

hey! i like fish too!

nice dress!

hubbah hubbah!

Love Potion #1 Love Potion #2 Love Potion #3 Love Potion #4 Love Potion #5 Love Potion #6 Love Potion #7 Love Potion #8

"When!"

*"I may know everything about art,
but I don't know what I like."*

Freaks

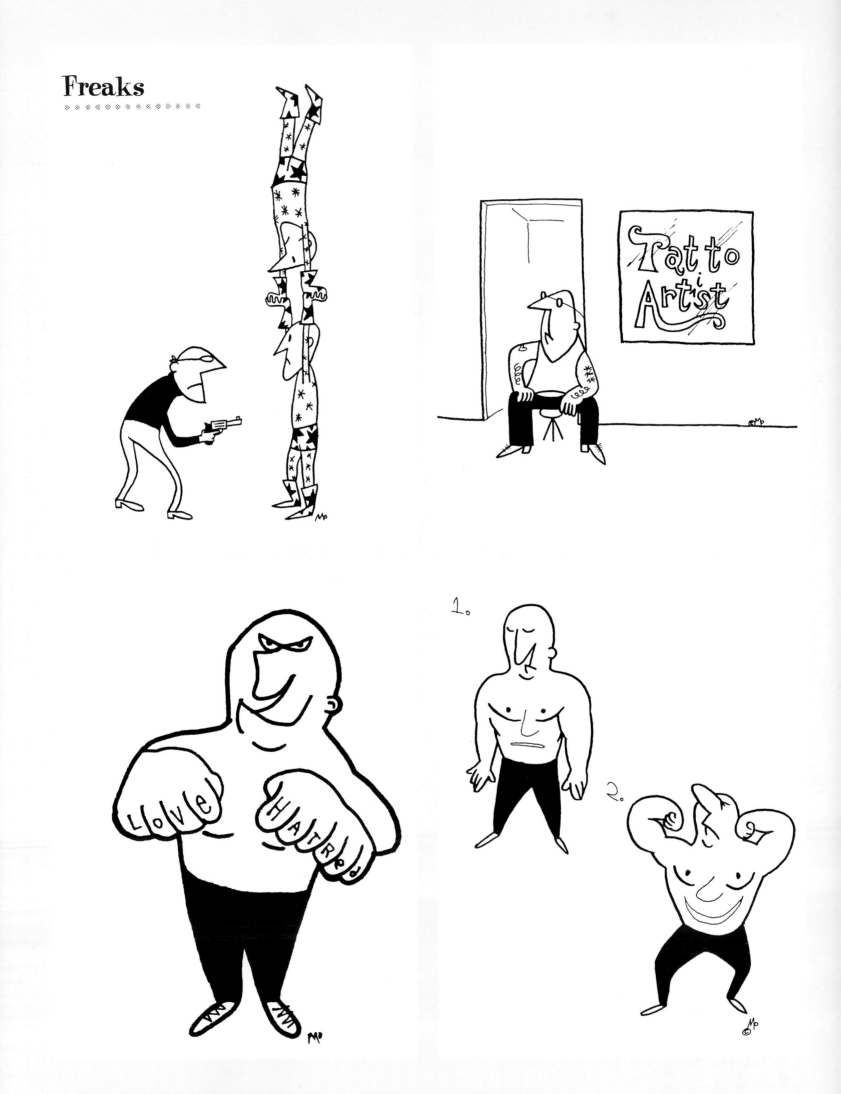

Extras

1.

2.

3.

4.

FUN FARE FOR FATALISTS™

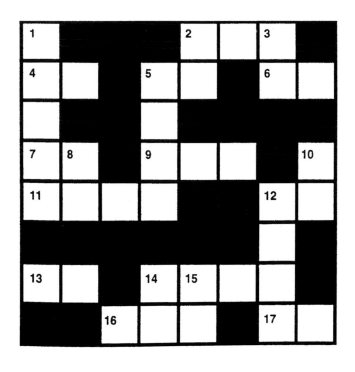

ACROSS

1. _____–I am
2. "Happy" in Sanskrit
4. Genghis _____ (not Khan)
5. Why are we here?
6. "Hello, my name is _____"
7. Number of men named Maurice in Zambia
9. Bob's favorite color
10. A secret

11. A word I just made up
12. The meaning of life is _____.
13. A meal that is not breakfast, lunch, dinner, brunch or a snack.
14. Unpopular song in 1952
15. *Love Boat* guest
17. Idi Amin's secretary

DOWN

1. Michael Caine's 423rd film
2. A three-letter word
3. When a tree falls in the woods, does anybody hear it?
5. Nostradamus got this wrong
6. Biblical word for "spark plugs."
10. Synonym for that plastic bit on the end of your shoelace
12. Undiscovered element
14. The type of music that the singer in a band says he plays.
15. My inseam (*Hint:* think metric)

3. THE MO WILLEMS SKETCHBOOK III

This booklet marks the first year Sam, the *Ersatz* editor, and I didn't have to personally collate and staple every copy. Through a friend of a friend, we found a cheap printer. Now all we had to do was lay out the art and wait for it to come back. Wow, talk about luxury!

Again, I took an idea from this sketchbook for a later comic. The Freak Show of the Less Than Bizarre (including the "Siamese Cat," "Bearded Man," "Slightly Paunchy Woman," and "Identical Twins") was repurposed a few years later for the Monkeysuit Comics collective, an anthology series featuring New York City animators, including *The Venture Bros.*'s Jackson Publick and a few guys who are now at Pixar.

"You know when you see an idea that you wish you thought of, and you smack yourself in the forehead? Looking through Mo's book gave me a concussion."

—Peter de Sève, award-winning illustrator and character designer

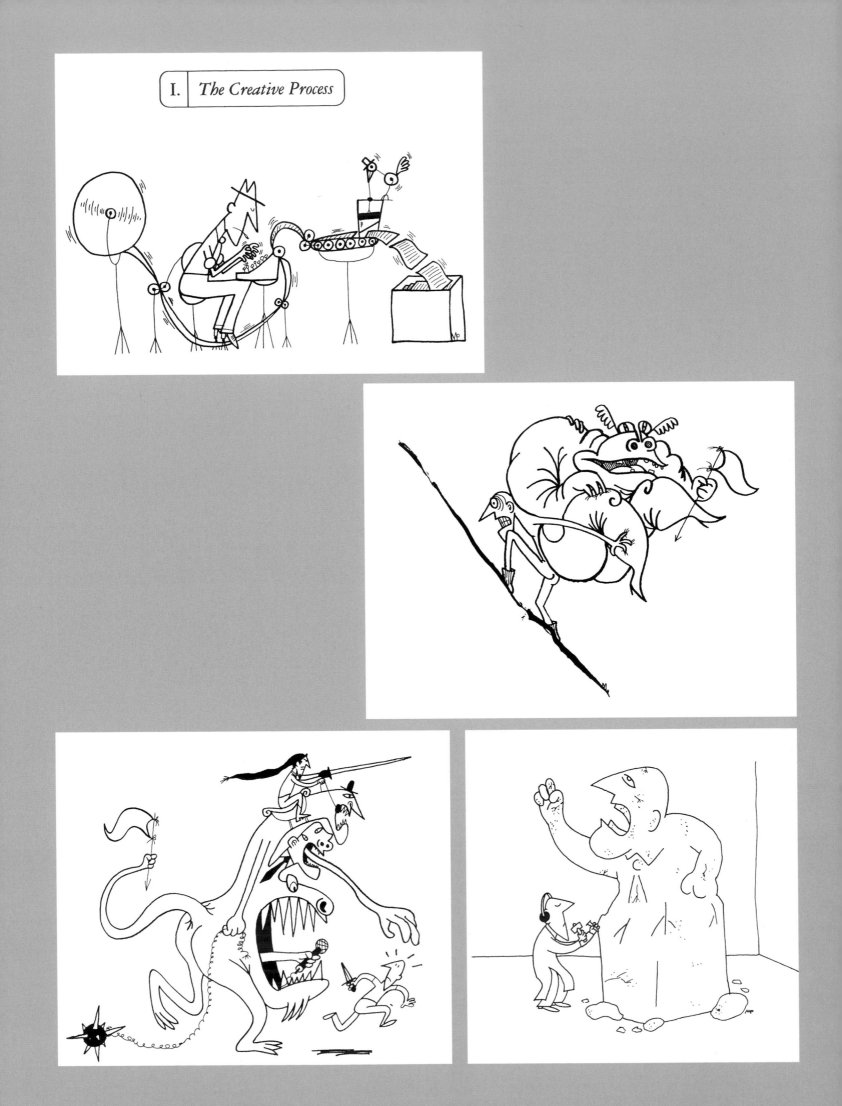

II. *Husbands Wives Lovers*

"My wife understands me."

"Harold!"

III. *Art & Artists*

The Fan

IV. | *Parks*

"*I see a major financial transaction.*"

"Table for one, only one, and nobody else, sir?"

"Don't look now, but I've got a weird feeling those eyes are following me around the room."

VI. | *Extras*

"*One word: Spring.*"

"I just want you to know that this is going to hurt me much more than it hurts you."

1.

2.

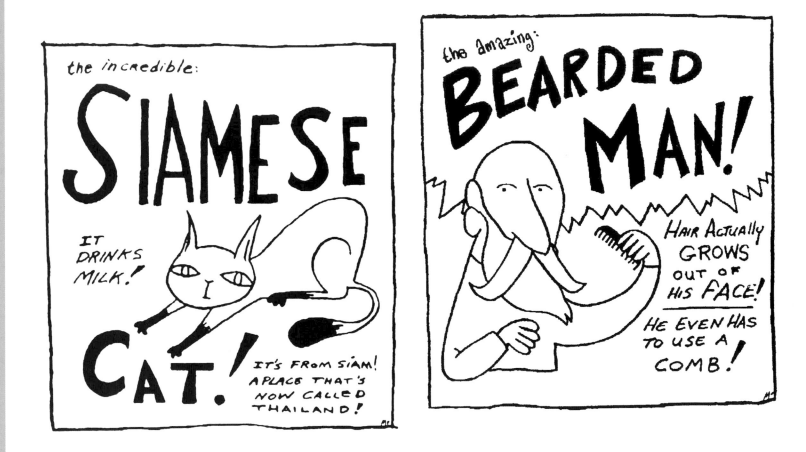

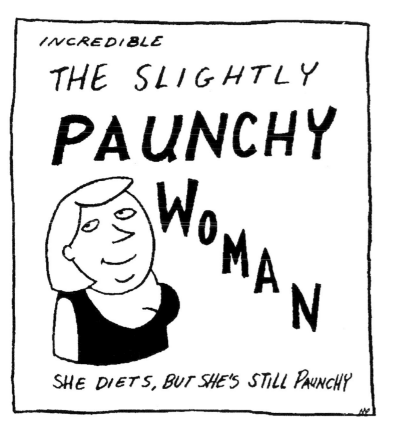

INCREDIBLE
THE SLIGHTLY
PAUNCHY
WOMAN

SHE DIETS, BUT SHE'S STILL PAUNCHY

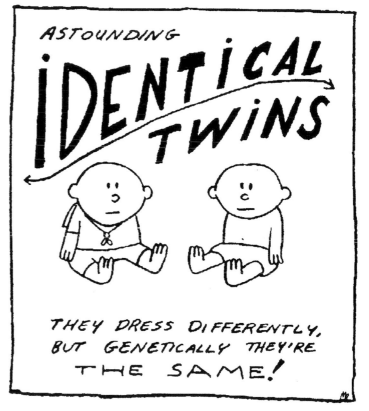

ASTOUNDING
IDENTICAL
TWINS

THEY DRESS DIFFERENTLY,
BUT GENETICALLY THEY'RE
THE SAME!

4. THE MO WILLEMS SKETCHBOOK IV

In this volume you'll see the influence of Anatol Kovarsky, an underappreciated cartoonist from the '50s. I'd found a few volumes of his work, even though most fellow cartoon-geek folks I know haven't heard of him. I love his line and simple, wordless work.

The sketchbook ends with an essay from my work with BBC Radio. I'd finagled a weird but very cool gig to write and record weekly pieces for a late night show that focused on American culture. Titled *A Postcard from Brooklyn*, the series was like Alistair Cooke's *Letter from America*. Only shorter. And not as good.

1. couples

2. bars & restaurants

"I'm sorry. I guess my eyes are bigger than my stomach."

"Hey, Bub! You lookin' at me?!?"

"Well, well! If it isn't Mr. Class of '86 Most Likely to Succeed!"

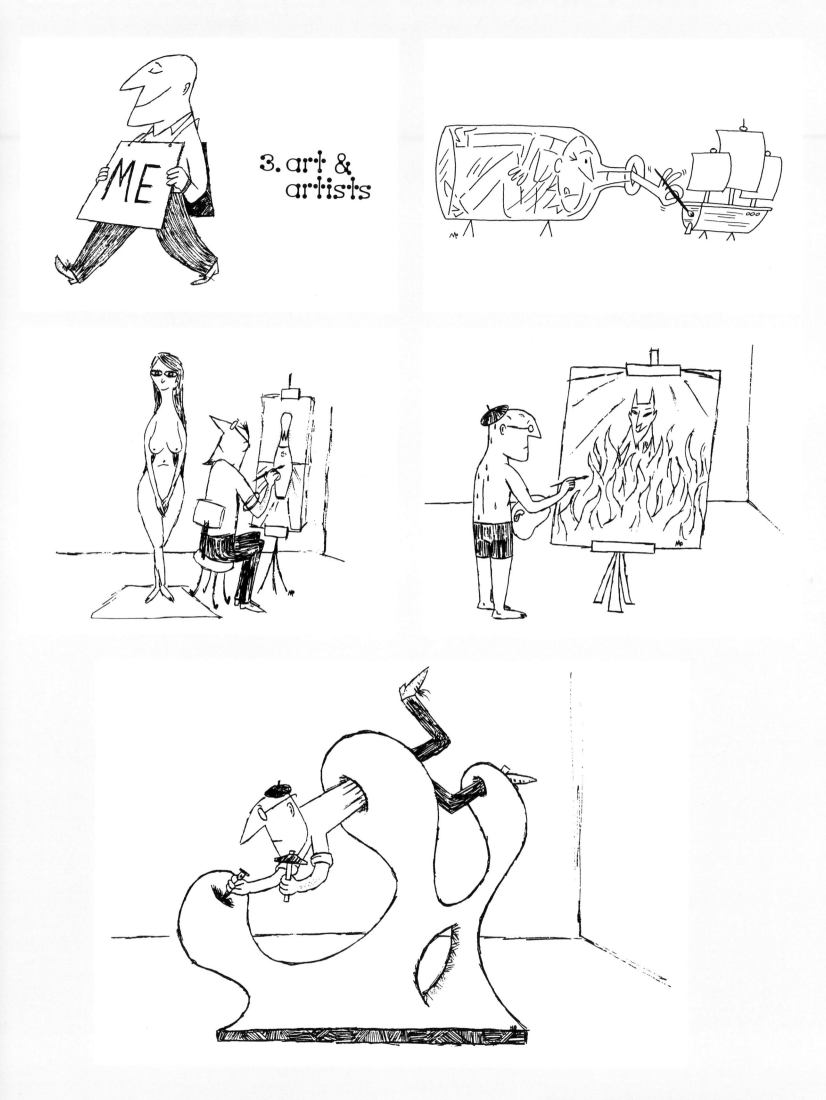

3. art &
artists

4. city life

"Are you <u>CRAZY</u>?!?"

WONDER BRA

ELECT
I. M.
LIAR

6TH DISTRICT

"The polls look bad, sir."

5. the workaday world

"You sunk my battleship!"

Snake in the Grass

surfing the web...

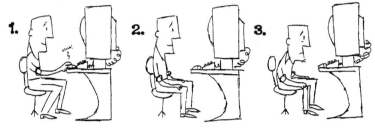

1. 2. 3.

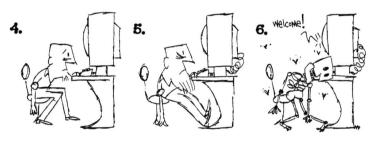

4. 5. 6. welcome!

6. dogs

"Wait a second—I thought I was your best friend."

7. interiors

When a New Yorker moves into a big apartment

John was beginning to think his answering machine might be broken.

"Why, yes, as a matter of fact, I _do_ have a little boy who's being very naughty."

"I think it's time we had a little talk about my allowance."

8. getting a haircut

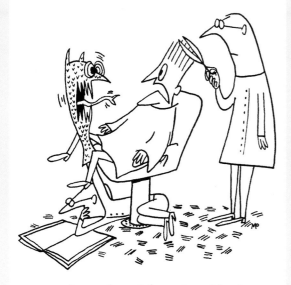

(a postcard from brooklyn)

> "there is <u>something</u> more insurmountable than a language barrier: the barber barrier."

Guess what? I went to a barber. Not a big deal, you say. Well, you're wrong. This was a big deal. A *very big deal.* A deal of gargantuan bigness. You see, this was the first barber I'd been to in over five years. Don't get me wrong, my hair has been cut in the last five years. In fact, it's been cut quite regularly. But not by a barber, by *me.* Sometime in 1990, I realized that there is something more insurmountable than a language barrier: the Barber Barrier.

Throughout the '80s, no matter how hard I tried, I could not get any barber on the planet to execute what I desired in a haircut. I'd explain exactly what I wanted in a slow clear voice, I'd bring photographs, sketches, schematics in all three dimensions, but to no avail. No matter what I did, my barber would cut my hair exactly like he or she wanted to cut it. And every time, I'd have to sit there and wait for the barber to finish butchering my poor head. Then when it was over, and the barber proudly pulled out a mirror for me to survey my new coif of death, I'd grit my teeth, smile, and say, "I love it."

What is it with barbers that makes it impossible to be honest with them? I can tell my girlfriend I don't like her outfit, I can tell my fellow writers that their favorite sketch stinks, I can even tell a friend that their child is ugly. But after a man I don't even know has finished transforming my head into a dork-o-rama, all I can say is, "I love it."

Maybe it's because he's holding the scissors. One time, and this is a true story, one of these so-called hair "stylists" accidentally shaved a big patch off the side of my head. I looked like a lobotomy patient or a doll owned by a sadistic little girl. But what did I do, sitting there while perfect strangers were asking me about my chemotherapy? Did I scream? Did I cram a bottle of hair gel down his throat? Did I gouge his eyes out with a six-year-old copy of *People* magazine? No, I said, "I love it," and ran out to buy a hat.

It's not surprising, then, that for five years I cut my own hair. I'm not very good, but at least I don't have to pay someone else to make me look silly. I would just snip here and snap there until I no longer looked like I had mange; then I'd look myself in the mirror, say, "I love it," and get on with my life.

So, why did I go to the barber this week? I have no idea; maybe because I'm stupid. That's the reason I do a lot of other stuff, so that must be it. I'm stupid. There I was, stupidly walking into my local Polish unisex haircutting establishment, face-to-face with the woman to whom I would sacrifice my dignity, the woman who could do in twenty minutes what an entire lifetime of tacky clothing could not accomplish.

I checked out her hair. I know she doesn't cut her own hair, but at least I could get a sense of her taste. Her hair had a bigness that staggered me. Like a lion's mane, it dominated the room, gelled and moussed to the point where it was sharp enough to puncture a tire. At least, I thought, if someone comes in shooting, her hair can deflect the bullets. My heart was beginning to sink, but because I'm stupid, I just smiled.

And then she spoke. In her best English, she asked, "How hair?" That's right, "How hair?" Now, you may not realize this, but there are very few possible responses to "How hair?" besides, "Like Eagle, sleek and friend to Caribou." But I didn't say that, no I just weakly tried to explain what I wanted and gave myself over to the gods. It seemed like an eternity, but when she finished, it didn't look half bad. Then I remembered I wasn't wearing my glasses.

If anybody knows a good place to buy hats in Brooklyn, drop me a line.

5. I'M FINE.

This sketchbook is the result of spending the year rereading and enjoying William Steig's *The Lonely Ones* while simultaneously going through a difficult time with my family. I thought I'd try, much like Steig had, to create drawings with quick brushwork that were subconscious.

Before I knew it, I had a bunch of scrawls and useless ink splotches. But among them, a few drawings emerged that spoke to me, and they seemed to fit together. So, I started titling the drawings and putting them in order.

On a design note, I still like how, like the subject matter, the words slowly descend page by page.

"Mo's brilliance lies in his ability to take the absolutely ordinary and make us see the amazing humor in it. His work exists in this world unselfconsciously and with just enough edge to make a reader ask 'Ooooh—is he really gonna go there?!' And then he does and we're SO glad he did. The magic is that Mo speaks to people across age, class, race, and gender. The grace is that he has such a deep respect for the importance of laughter."
—Jacqueline Woodson, celebrated children's book author

...I need to take a good,
hard look at myself...

...I'm confused...

...I am going to be
 completely honest...

...I need an outlet for my anger...

...I've got to get a grip...

...I'll never live up
to my expectations...

...I'm useless...

...I fear the future...

**...How did I get myself
into this situation...**

**...I have to focus on what's
important...**

...I yearn for beauty...

...I'm not interested
in your special offer...

...You don't scare me...

...I can't help myself...

...I don't care anymore...

...I asked them to leave me
alone, and they did...

...I know they're talking
about me...

...This never happens to
other people...

...This too shall pass...

...Who am I kidding...

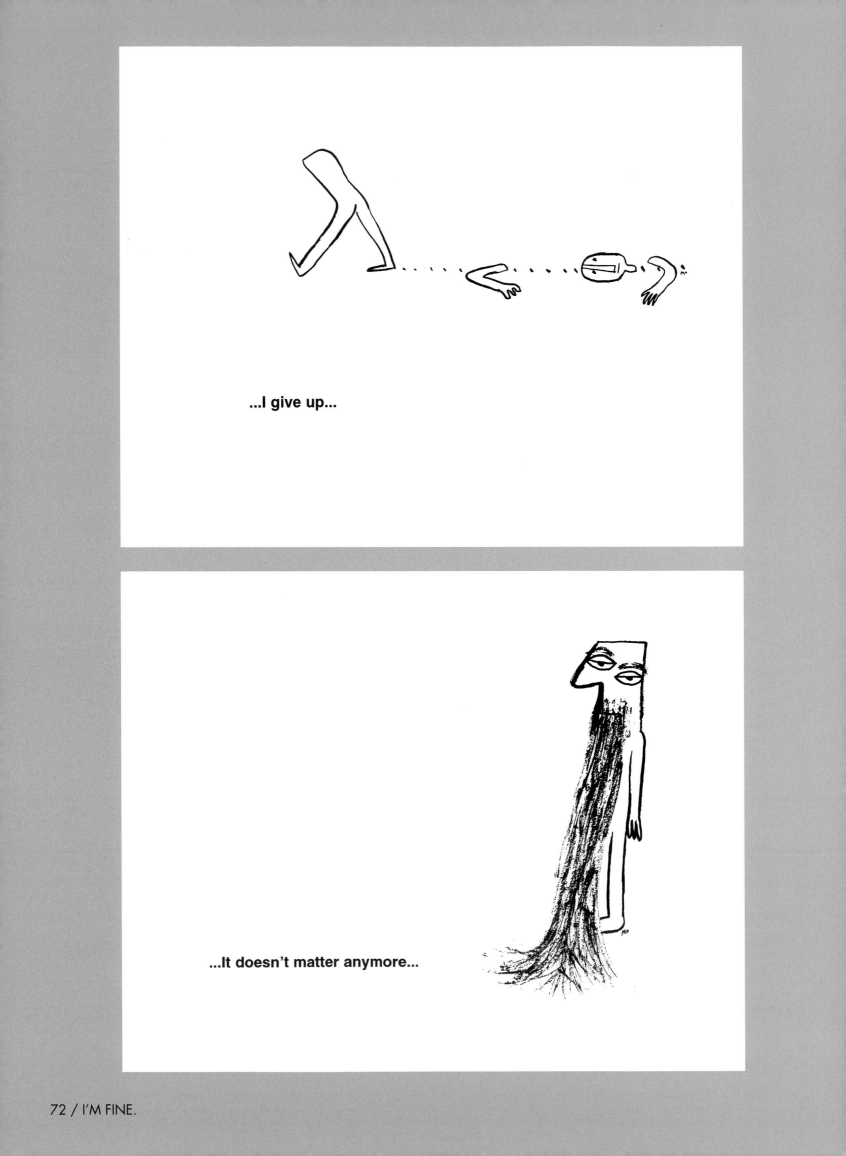

...I give up...

...It doesn't matter anymore...

...Is it over?

6. DON'T LET THE PIGEON DRIVE THE BUS!

The Pigeon, who would years later star in my debut picture book, was born in the corner of a notebook, complaining about how he was better than the other doodles I was making. That summer, my wife and I had taken a month off in Oxford, England, so that I could attempt to turn some of my ideas, none of which included the Pigeon, into a children's book.

Exasperated by his outbursts in the margins of my sketchbooks, I decided to try to put him in a story. The original idea for the story featured a little boy tasked with the job of not letting the Pigeon drive the bus. But that was no good for the Pigeon. He wanted to star, alone.

Turns out, the Pigeon was right. When I cut the kid, the story came to life.

But it didn't occur to me that children might enjoy the Pigeon's antics until my wife started reading the sketchbook at the elementary school library where she worked part-time. Even so, I was surprised when, a few years later, an agent suggested I dump the other ideas I'd come up with in England and start reworking this sketchbook as a picture book.

The published version of *Don't Let the Pigeon Drive the Bus!* features tighter design, but retains much of the sketchy quality and content of this sketchbook. Rereading it, I was surprised that the story had no ending whatsoever. Later pitch versions of it ended with the Pigeon wanting an airplane for the final reveal, but we finally settled on a semitruck.

"*Don't Let the Pigeon Drive the Bus!* was a game-changer in picture books. It ripped away all adult condescension and sentimentality and channeled pure, glorious, childlike id."
—Alessandra Balzer, co-publisher of Balzer + Bray, editor of *Don't Let the Pigeon Drive the Bus!*

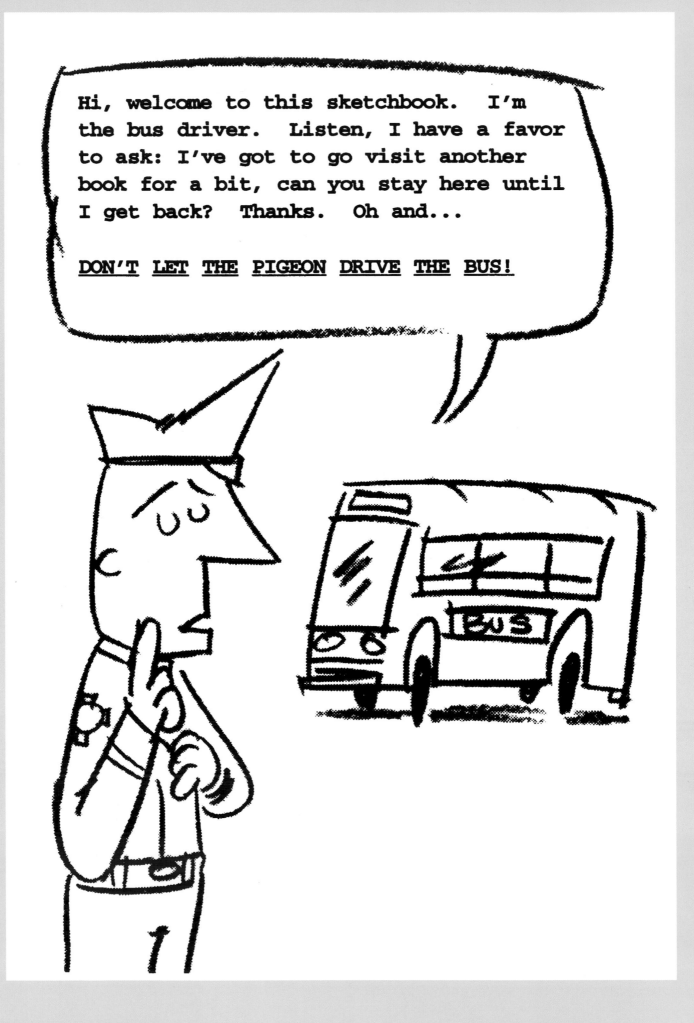

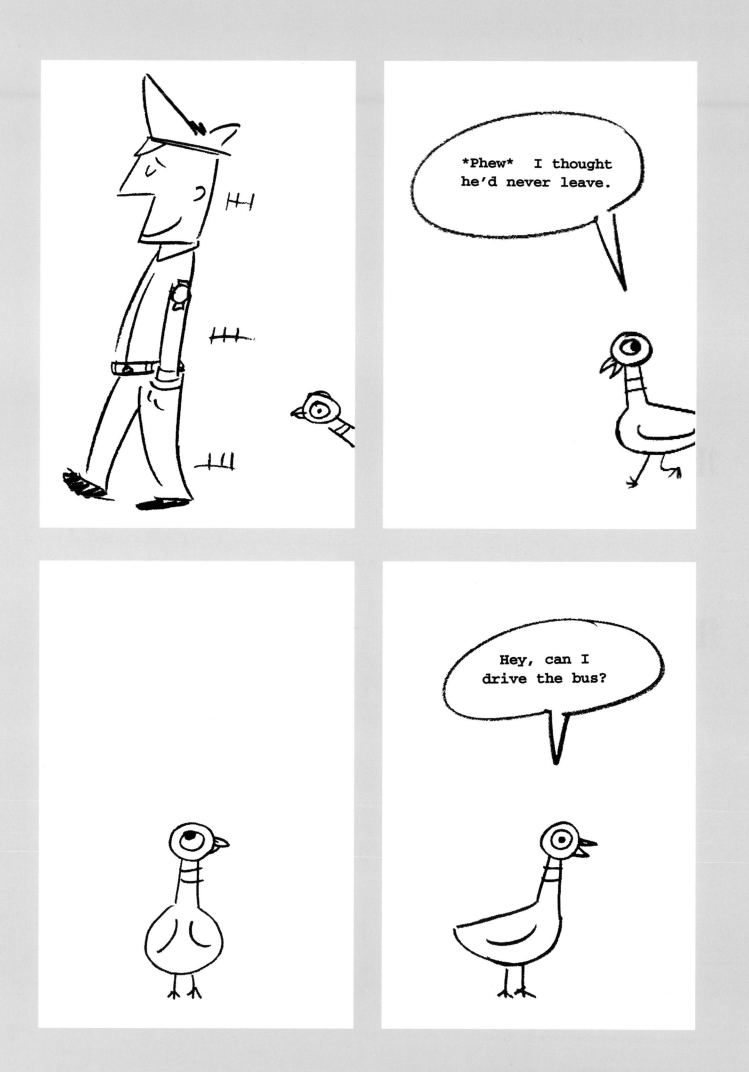

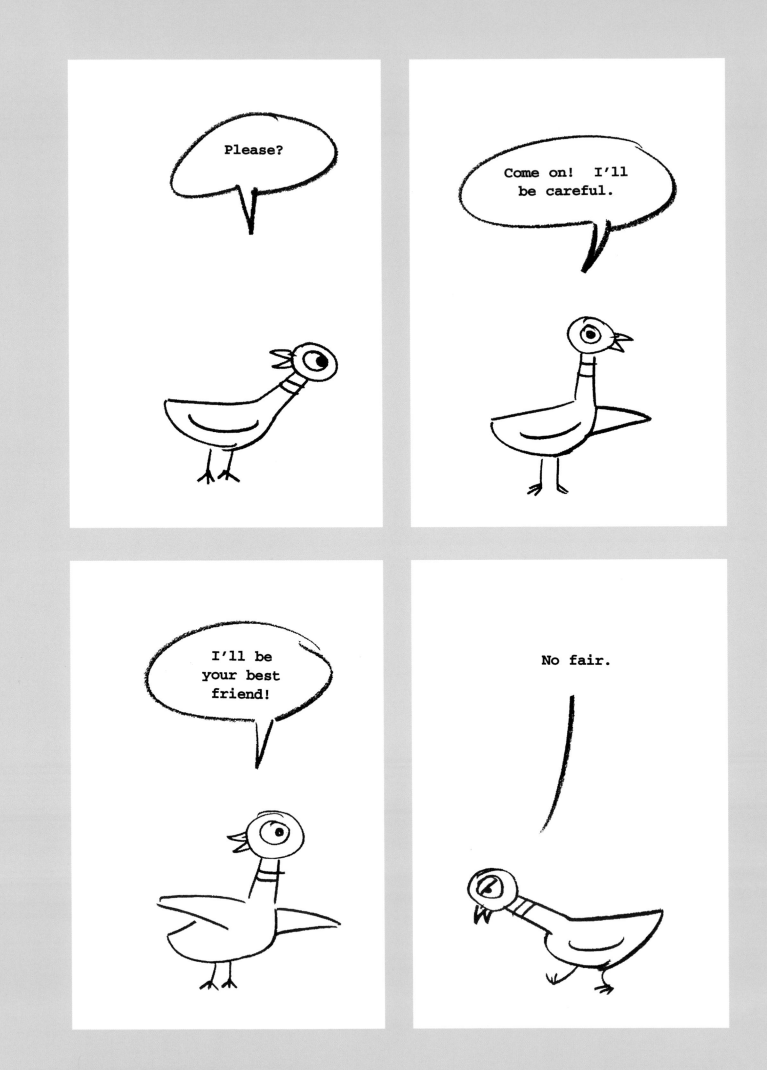

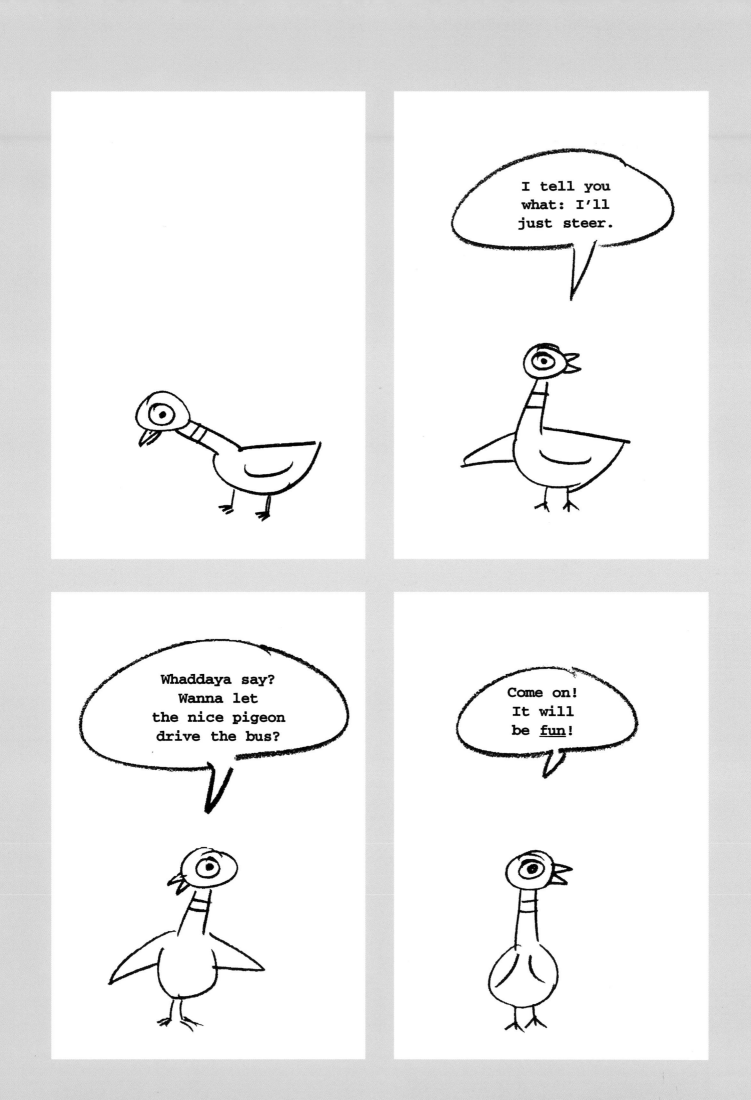

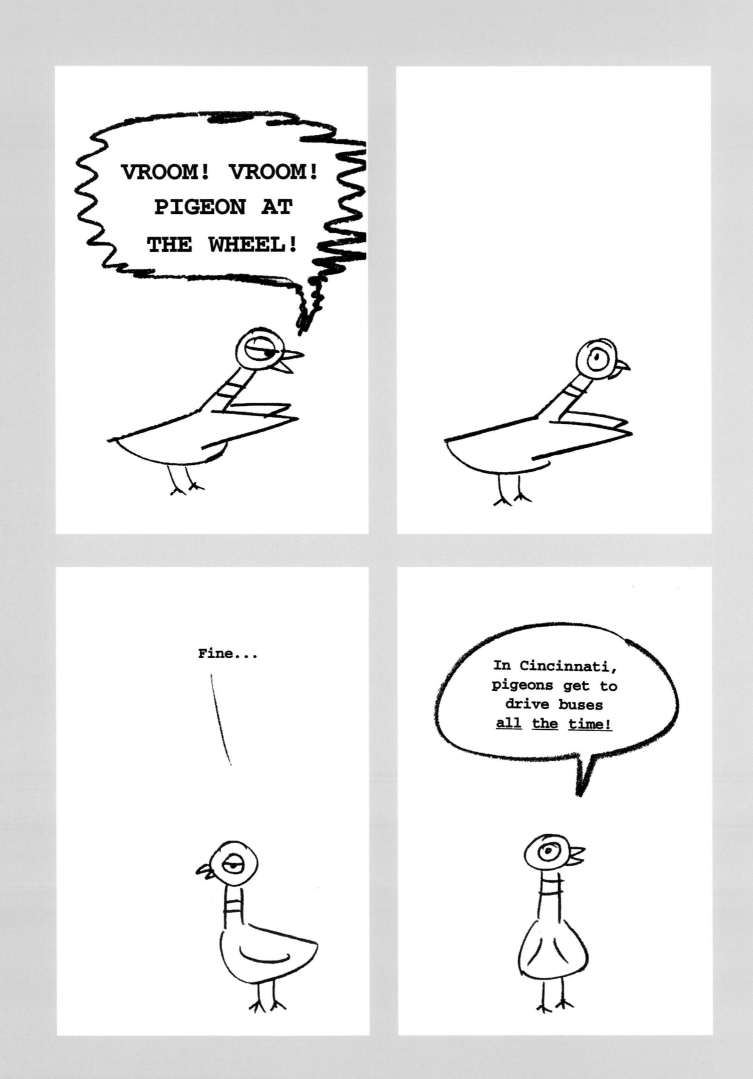

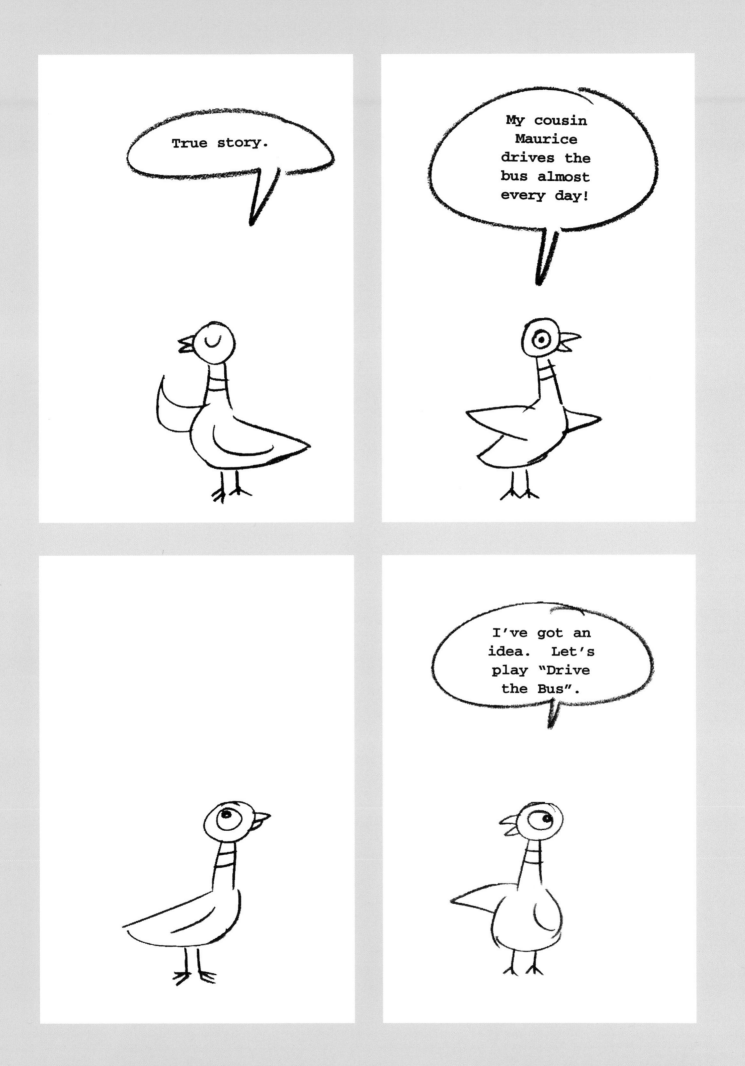

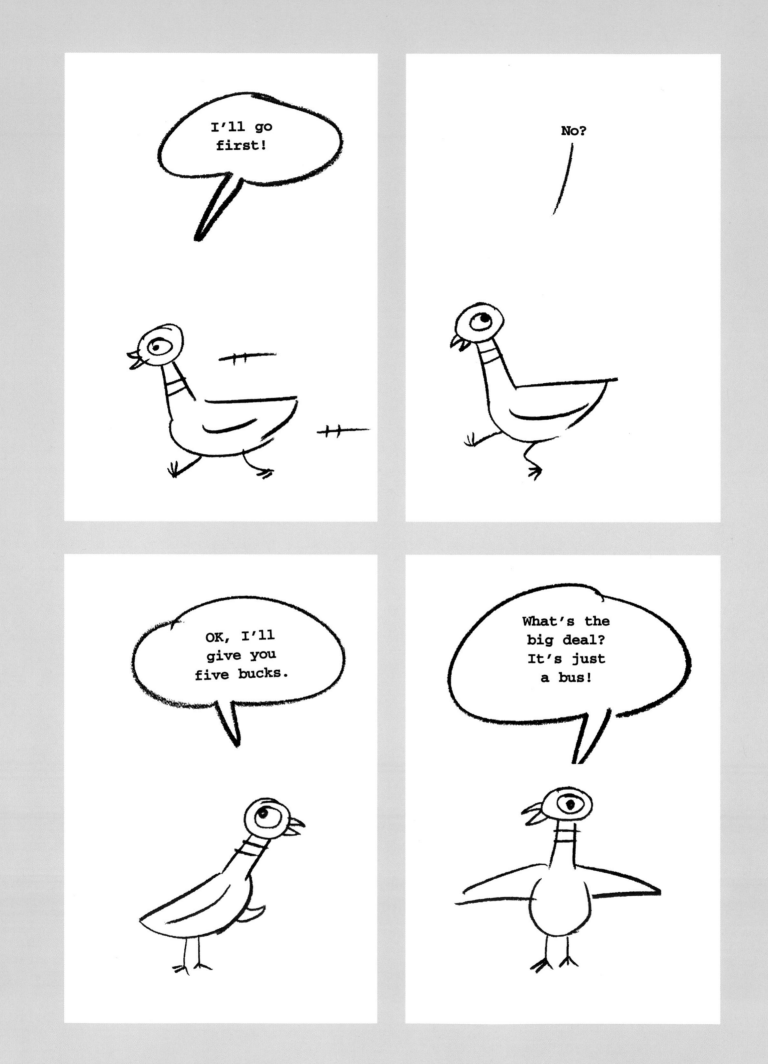

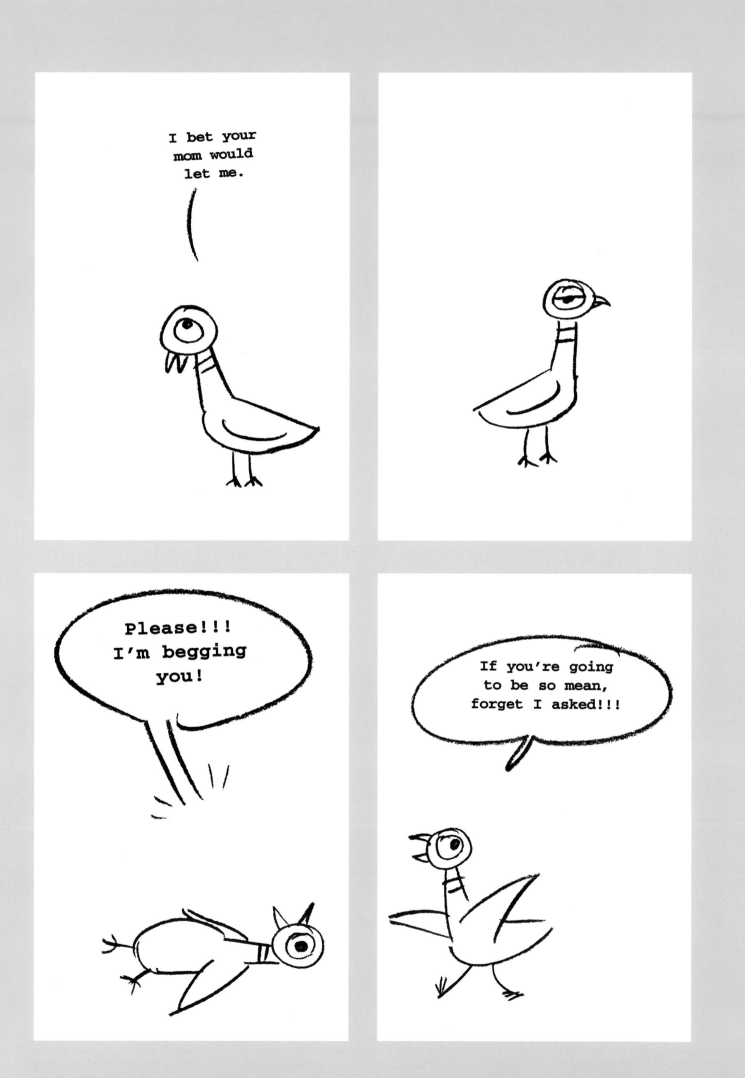

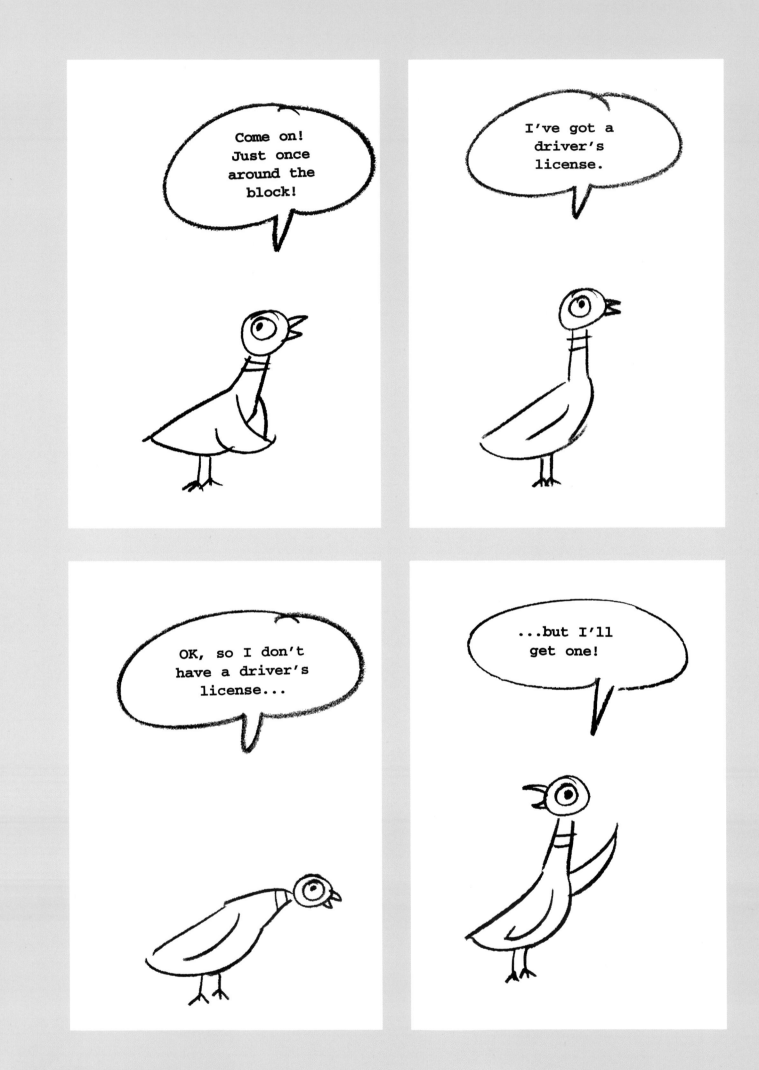

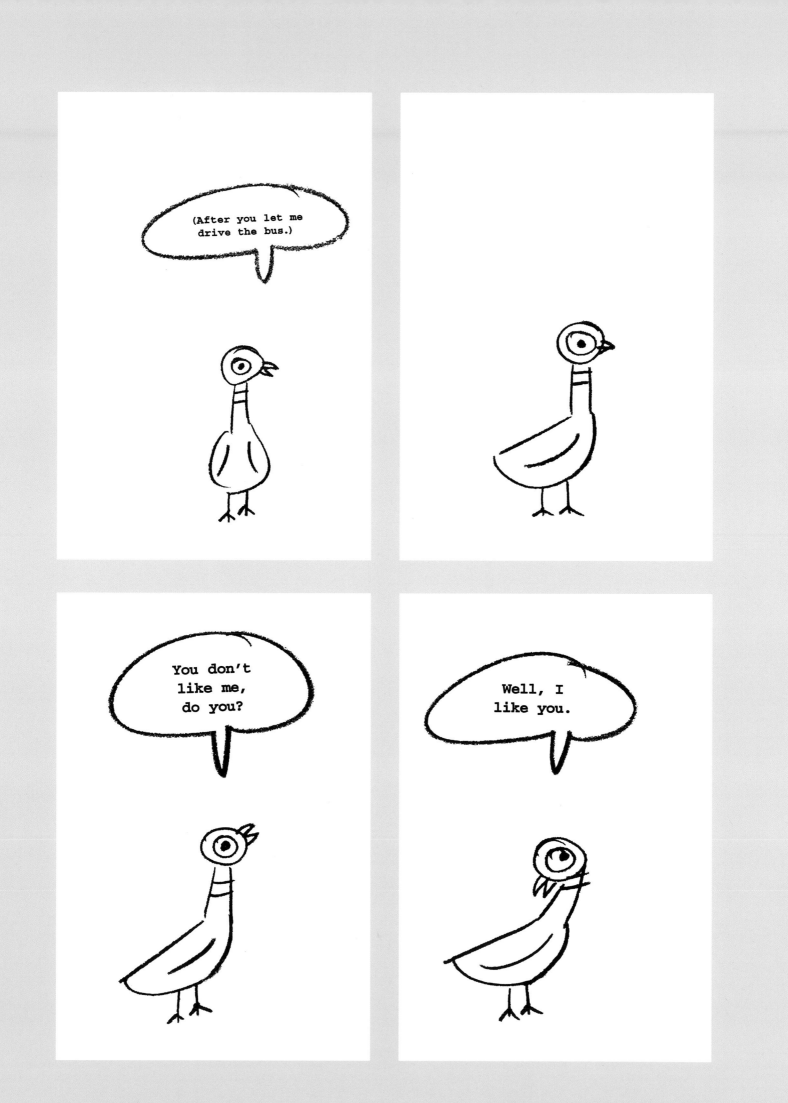

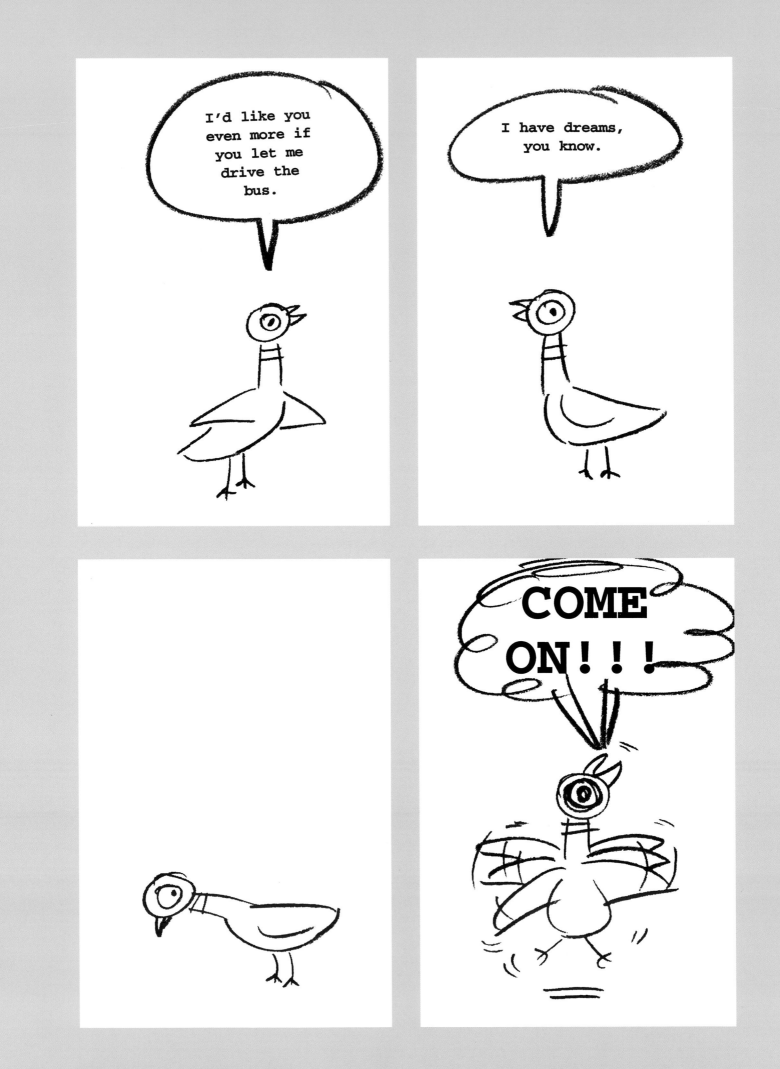

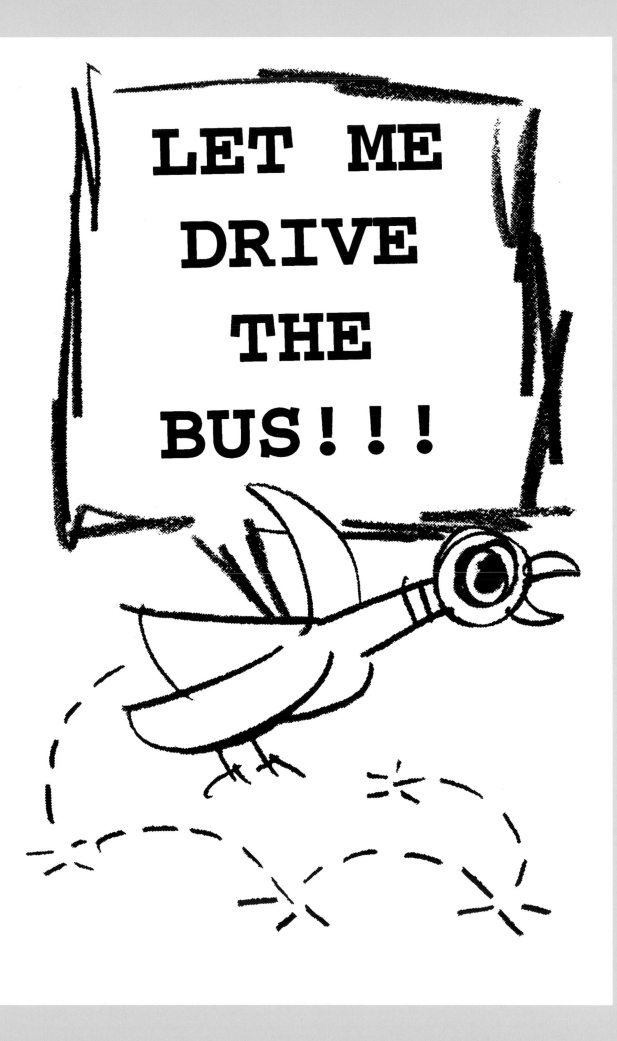

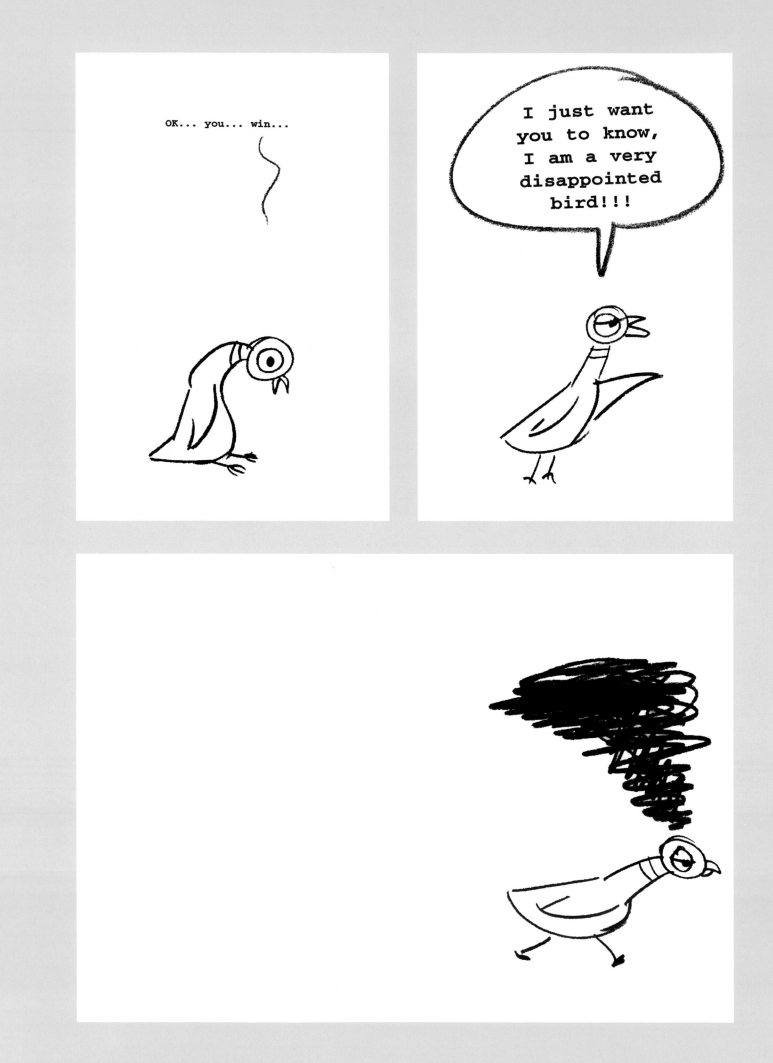

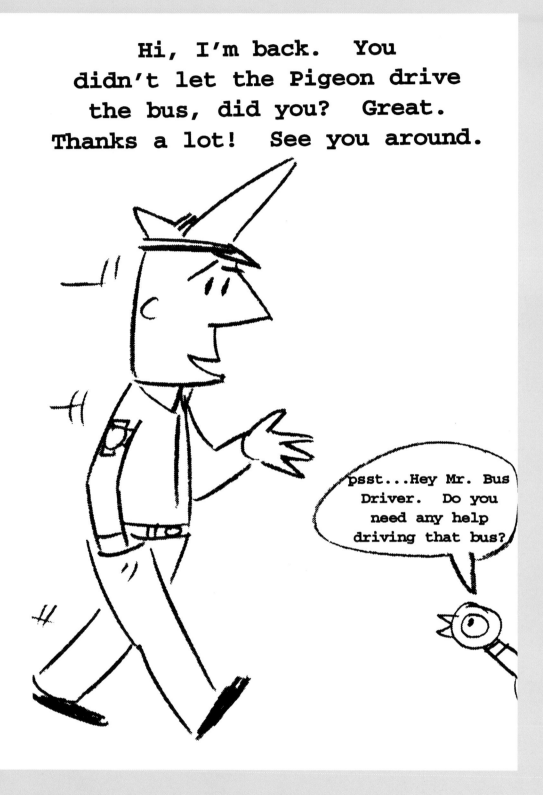

7. WISE THINGS

I suppose an Edward Gorey influence snuck up in this series of somewhat grim jokes. I've always enjoyed Mr. Gorey's work.

But it's more likely that this book came from a reaction to overworking. I'd spent so many years drawing little kids at all hours of the day and night and on weekends, both for my work on Nickelodeon and on *Sesame Street*, and now was starting up production of *Sheep in the Big City* for Cartoon Network. I was so tired of rendering jolly round-headed scamps that my subconscious just wanted to kill them. Which it did in this volume.

A side note: "The Lucky Penny" is one of my favorite short stories.

curious pictures presents:

WISE THINGS

a *mo willems* sketchbook.

"Mo Willems is the most brilliant cartoonist I know, for his height."
—Dave Barry, Pulitzer Prize–winning author and columnist

1. Dinner.

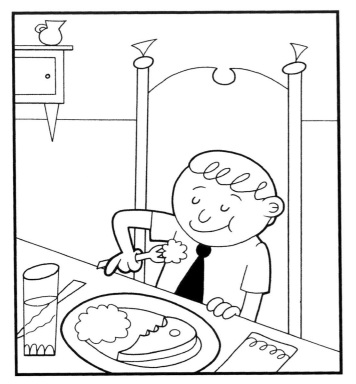

"Wise Things always eat everything on their plate."

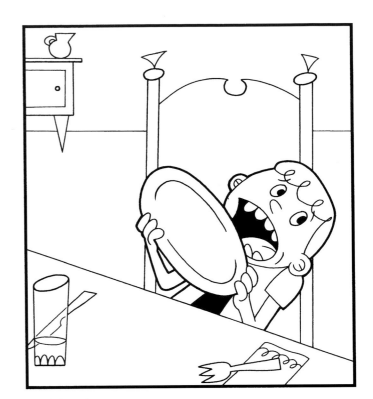

"And then they stop."

2. Advice for the boys.

"Boys, do not try to grow a beard."

"Kids ignore weirdos."

3. A personal warning.

"Do not pin your hopes on a wish."

"You may be disappointed."

4. A rule of thumb.

"Litigation is not always the answer."

5. Manners.

"Wise Things always offer someone else the first piece of cake."

"It might be poisoned."

6. A thing to remember.

"These are the best days of your life."

"Sorry."

7. The Lucky Penny.

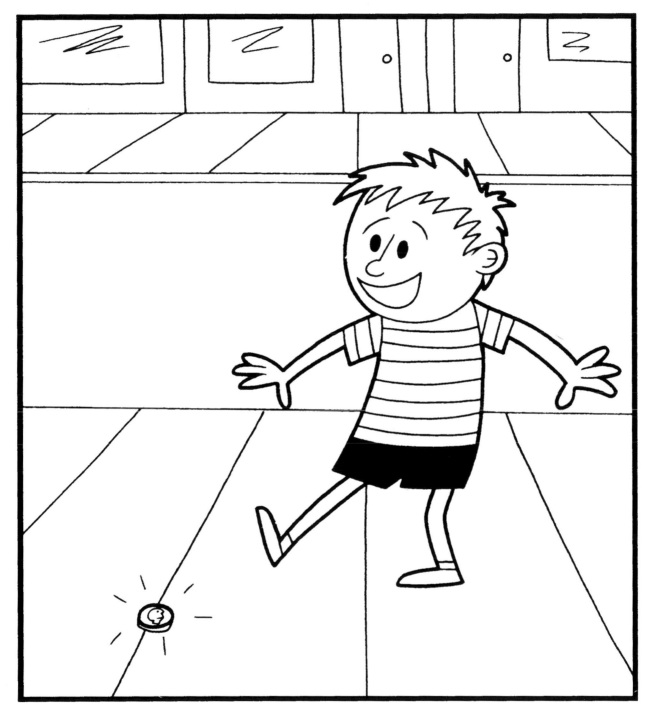

One day, a boy found a penny on the street.

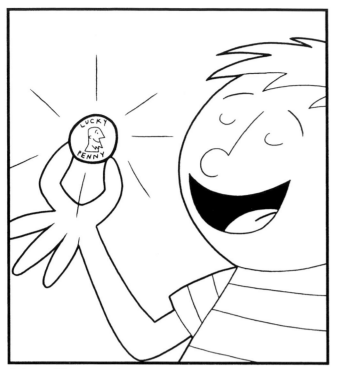

"This will be my Lucky Penny!" the boy said.

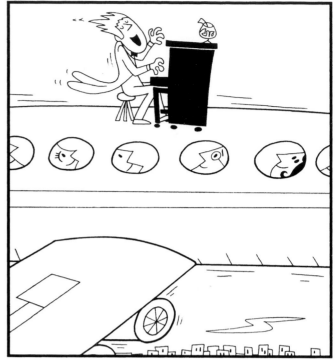

Just overhead, a man was playing a piano on top of an airplane going to Detroit.

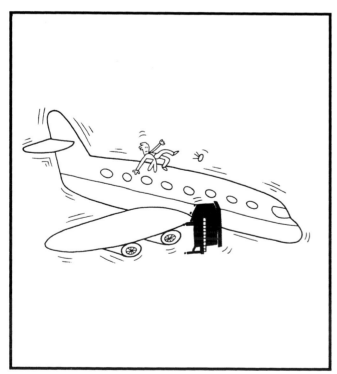

Suddenly, the airplane hit a patch of turbulence, and the piano fell off.

The piano fell toward the boy at tremendous speed.

The Lucky Penny wasn't even scratched.

8. Advice for the girls.

"Girls, be wary of boys who grow beards."

9. So very true.

"It's all fun and games..."

"...until someone loses an eye..."

"But if someone finds the eye..."

"...it's all fun and games again."

10. A parting thought.

"If ever in doubt ..."

"... ask for cash."

8. THE LITTLE BAD WOLF

Like *Don't Let the Pigeon Drive the Bus!*, this year's sketchbook would ultimately become a launchpad for a picture book. I'd been playing with the character of the Little Bad Wolf for a number of years, doodling him, putting him in odd situations, and finally turning him into the star of a comic strip pitch. These were all attempts to break the story about a weak outsider trying to find his way to some sort of redemptive less-than-bad badness.

It was frustrating not being able to find a place for this guy, whom I really liked. Finally giving up the idea of doing anything useful with the Little Bad Wolf, I let him be the protagonist in this volume as a consolation prize.

A few years later, my young daughter burst into my studio and growled, "Roar! I'm a terrible monster!" Of course, she wasn't; she was adorable. But that instance was the spark I needed. What if instead of a Wolf, the unaccomplished baddie was a Monster? A Terrible Monster? I already knew the character; I just hadn't known what type of creature he was. Very quickly, I turned my old notes into a new picture book story: *Leonardo, the Terrible Monster*.

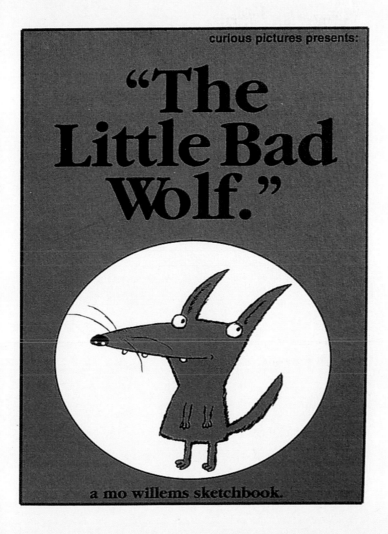

curious pictures presents:

"The Little Bad Wolf."

a mo willems sketchbook.

"Humor and creativity seem to flow from Mo Willems in a torrent."
—Jeff Kinney, author of *Diary of a Wimpy Kid*

1.

An Introduction.

This is the Little Bad Wolf.

He works as a Telemarketer.

He loves his work.

Especially on weekends.

2.

Attention
to detail.

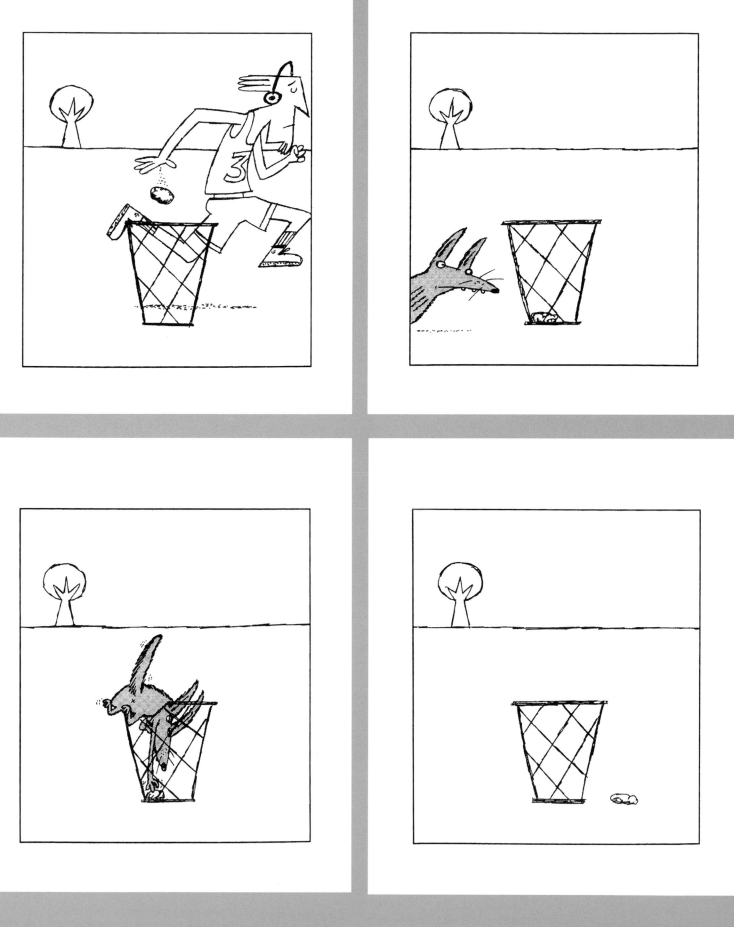

3.
Hobbies.

The Little Bad Wolf likes to recommend music that sucks.

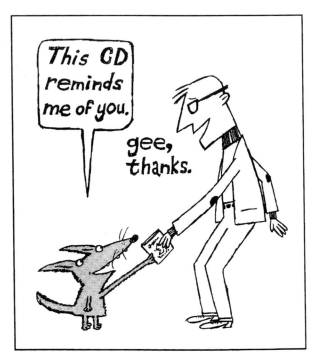

He volunteers his time sliding Chinese menus under apartment doors.

Sometimes he translates during sensitive peace talks.

4.

Never underestimate a classic.

5.

Hopes and Dreams.

The Little Bad Wolf would love to be an Air Traffic Controller at LaGuardia Airport.

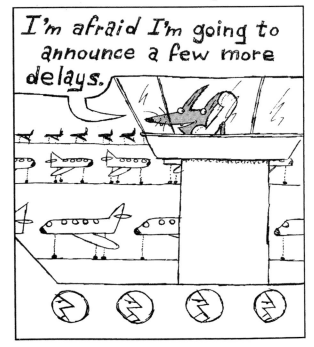

He dreams of creating a new video format to make DVDs obsolete.

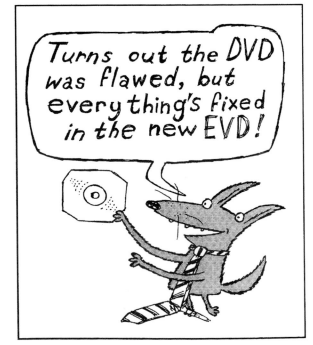

He would like to be a Television Programmer.

But all that really matters to the Little Bad Wolf is enjoying the simple pleasures in life.

9. THE PIGEON TELLS A STORY

By this time, I had a book agent, but she was having no luck shopping around a revamped *Don't Let the Pigeon Drive the Bus!* as a picture book. Everyone said the same thing: "It's unusual." (Alessandra Balzer, the editor who eventually picked up the book, also thought it was unusual; she just didn't think being unusual was pejorative.)

Originally, I'd planned on doing a sketchbook entitled *The Little Engine That Couldn't*. But ultimately, it seemed more fun to have an untrustworthy, biased narrator steer the story. As I was certain that the Pigeon wouldn't get a chance in the real world of publishing, I decided to let him star in this one.

Also, I hate drawing trains.

"The Pigeon
Tells A Story."

a mo willems sketchbook.

"My kids love Mo Willems. His books make us laugh
our butts off...no easy task!"
—Jack Black, actor and musician

OK, here's a story for you...

Well, you see, one day this little choo-choo was overloaded with important passenger cars and cargo and stuff...

And she was chugging along, until she turned a bend on the tracks and saw this big old hill.

"Wow, that's one big old hill," said the choo-choo. "I hope I'm strong enough to go over it!"

Well, that sure surprised the engineer, who had no idea his choo-choo could talk. Surprised him so much, in fact, that he jumped off the speeding engine, injuring himself terribly.

What could the
little choo-choo do,
but re-double her
efforts?

"I think I can!"
she said.
"I think I can!
I think I can!"

And chanting like
that, she sped
towards the very
big old hill.

By now the passengers
were getting a little
concerned, what with
that choo-choo yelling
"I THINK I can!
I THINK I can!
I THINK I can!"
at the top of her voice.

One of the passengers said, "Who the heck put that little choo-choo on this hilly route? It's not like that big old hill just sprang up yesterday out of nowhere!"

The other passengers had to admit that the first passenger had a point, but the choo-choo kept on speeding towards the big old hill yelling: "I THINK I CAN! I THINK I CAN! I THINK I CAN!"

But she couldn't.

KA-BOOM!

The poor, deluded choo-choo blew up and started barreling backwards down the big old hill!!

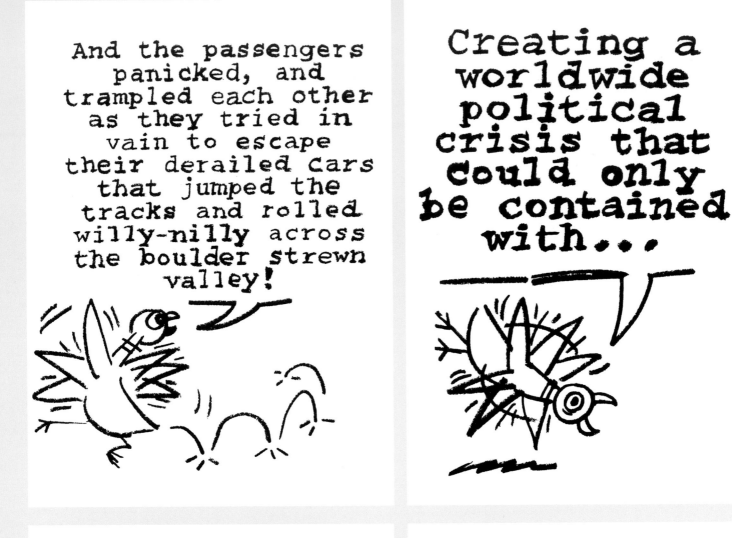

10. LAZY DAY DOODLES

These doodles are the product of a particularly busy year. I found myself facing a steep learning curve as I produced my first books for Hyperion Books for Children (*Don't Let the Pigeon Drive the Bus!* and *Time to Pee!*) while keeping my day job writing for various TV concerns, in addition to writing and drawing the occasional comic book story for DC Comics.

I was also a new father (another very steep learning curve).

Exhausted and frazzled, I turned to doodling for a release. These drawings were made with zero forethought, simply gliding off of the pen onto the page. It was wonderfully relaxing compared to the pressure inherent in all of my other work.

lazy day doodles

pissy-missy

heads-up

i-don't-understand-a-word-you're-saying

difficult-commute

strange-flower

face-lift

where?

3-heads-are-better-than-1

one-small-step-for-mouse...

masochist

august

insomniac-hibernator

la-la-LAAAAA!

showers

roar!

shave

the-eyes-have-it

buggy

home-on-the-range

11. HERE COMES TROUBLE...

One of the keys to producing an entertaining picture book is the placement of art in relationship to when the page turns. The next page can be a continuation of what has been presented before, or it can be a radical change in time and place. Much like the editing of a film dictates the pace of the movie, the page turn is where a book's rhythm happens.

This sketchbook is a simple exercise in making connections with page turns, which I suppose was on my mind as I found myself making more books and less TV.

a mo willems
sketchbook.

here comes

trouble...

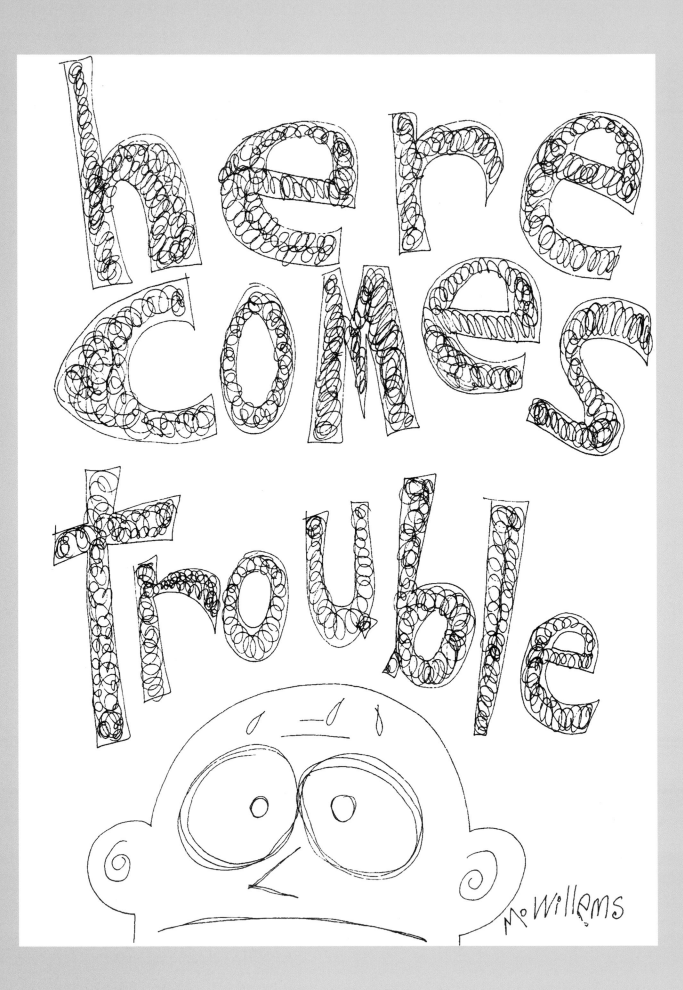

A box...

Pandora...

A two-year-old...

practically anything...

A bunny...

Three bunnies...

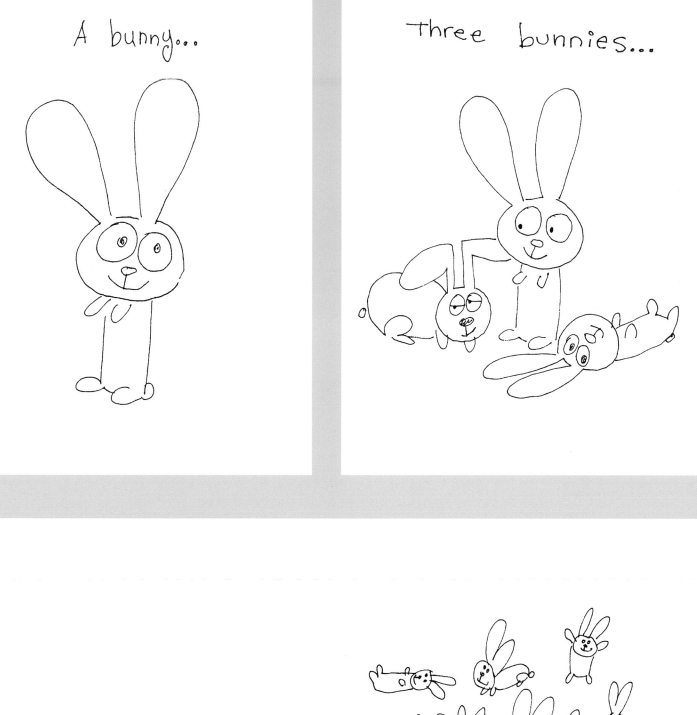

eighteen bunnies...

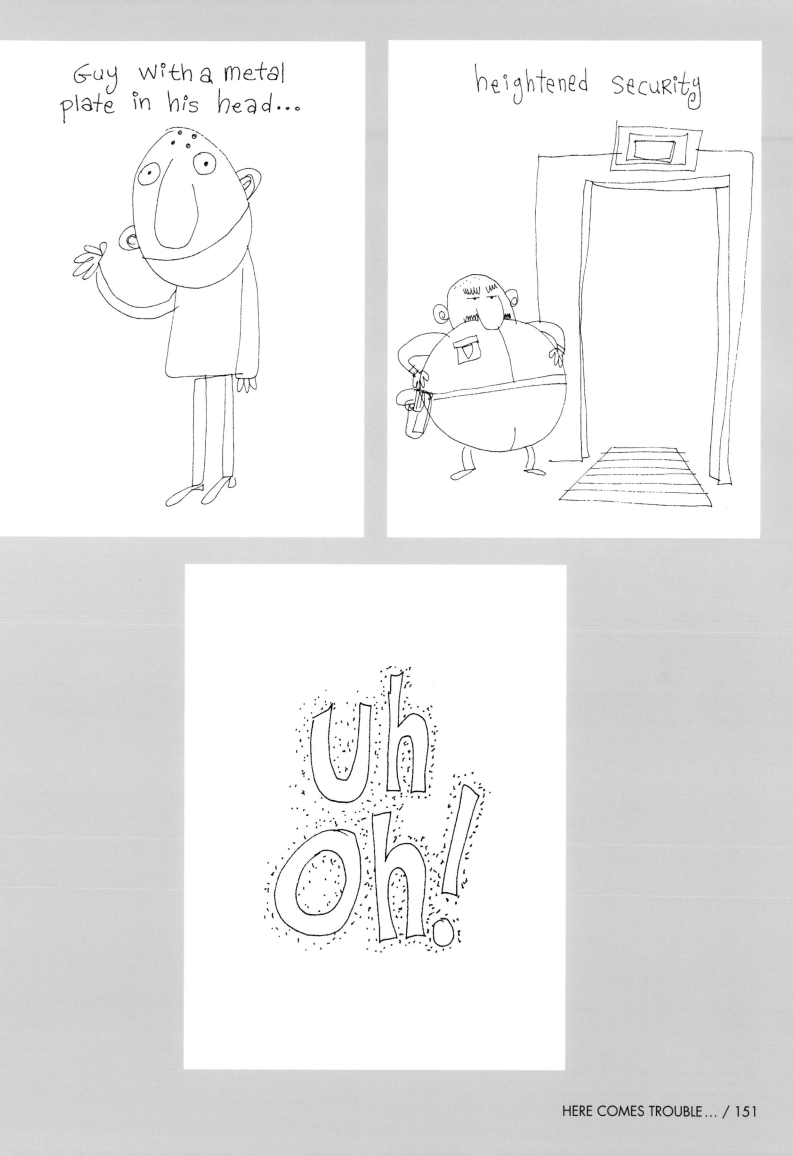

12. GOLDILOCKS AND THE THREE DINOSAURS

Only very seldom can a whole story come out of a silly title. In this case, I just let the story go wherever it wanted, and had a ball doing so. I suppose the rhythm of the piece came out of the nonsensical stories that I found myself telling my daughter at bedtime, although this sketchbook is clearly not for kids.

This was drawn at the same time that I was working on *Leonardo, the Terrible Monster*. I loved the type I was using in *Leonardo*, so I used it again.

Just a few years ago, I came back to *Goldilocks and the Three Dinosaurs* as the premise for a children's book with the same title. Obviously, the content had to be reworked. Also, the picture book required a bit more depth in terms of the characters and the underlying themes.

I suppose that's the difference between these sketchbooks and a proper book.

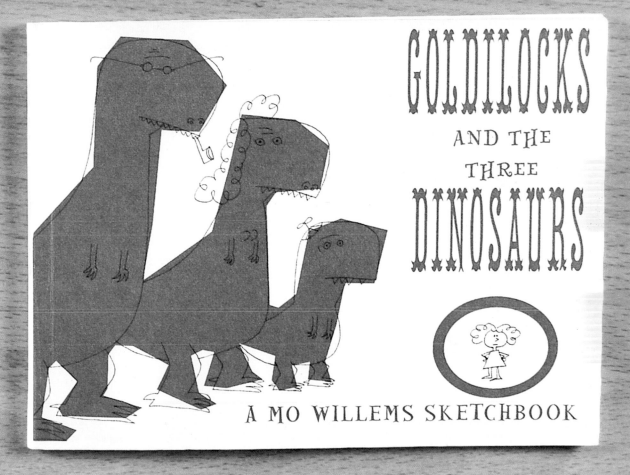

"Elves take all forms, as it turns out. Even tall, gray-bearded artists. The postman brings all sorts of gifts each holiday season, but none is more anticipated at the Pearson household than a small little book full of laughs and the twisted storytelling of Mo Willems. My guess is that Santa threw him out of the workshop a long time ago for his irreverence and tongue-in-cheek approach to life, but it's the North Pole's loss, and our gain."

—Ridley Pearson, *New York Times* best-selling author

GOLDILOCKS
AND THE
THREE
DINOSAURS

A MO WILLEMS SKETCHBOOK

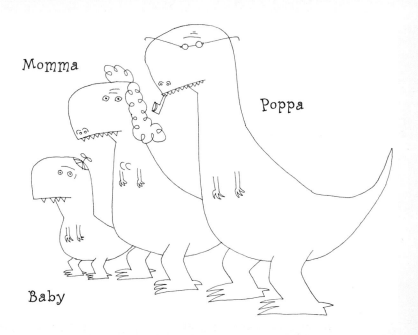

Momma

Poppa

Baby

ONCE UPON A TIME,
THERE WERE THREE DINOSAURS.

A POPPA DINOSAUR,
A MOMMA DINOSAUR,
AND A BABY DINOSAUR.

ONE DAY, THE DINOSAUR FAMILY
DECIDED TO GO CATCH A FLICK
OVER AT THE IMAX THEATRE,
WHICH WAS THE ONLY PLACE
IN TOWN WHERE THEY COULD
SEE ANY OF THE SCREEN.

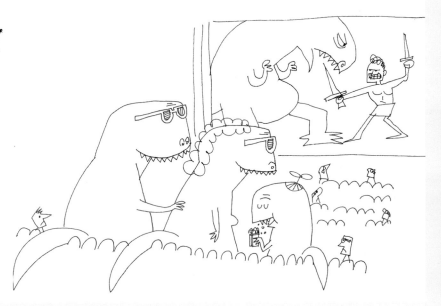

SOON, A POORLY SUPERVISED
LITTLE GIRL NAMED GOLDILOCKS
HAPPENED UPON THE DINOSAURS'
RESIDENCE.

SHE NOTICED THREE BOWLS OF
RODENT, STEGOSAURUS, AND EGG
PAELLA ON THE KITCHEN
COUNTER. BEING A GIRL WITH
ABSOLUTELY NO BOUNDARIES,
GOLDILOCKS CLIMBED UP A
STEP STOOL TO CHOW DOWN.

FIRST, SHE TRIED THE POPPA
DINOSAUR'S BOWL.

"OW! THIS, UH, STUFF IS TOO HOT!"
SAID GOLDILOCKS.

THEN, SHE TRIED THE MOMMA
DINOSAUR'S BOWL.

"UGH! THIS IS TOO COLD!"
SAID GOLDILOCKS.
GOLDILOCKS WAS OBVIOUSLY THE
KIND OF GIRL WHO ALWAYS ASKED
FOR SUBSTITUTIONS WHEN SHE
ORDERED IN RESTAURANTS.

THEN, SHE TRIED THE BABY
DINOSAUR'S BOWL.

"GROSS!" SHE SAID, SPITTING OUT
THE FOOD. "RODENT, EVEN WHEN
SERVED AT THE PROPER
TEMPERATURE, ISN'T MY
CUP OF TEA."

GOLDILOCKS DECIDED TO GO INTO
THE LIVING ROOM, WHERE SHE
SAW THREE GIGANTIC CHAIRS.

"UH," SAID GOLDILOCKS, "ALL OF THE CHAIRS ARE HUGE, SO I'M JUST GOING TO SKIP OVER THIS PART, 'KAY?"

GOLDILOCKS WAS TIRED AND MARCHED
INTO THE BEDROOM, WHERE THERE
WERE THREE BEDS.
THE DINOSAURS LIVED IN MANHATTAN,
AND THIS BEDROOM SETUP WASN'T
EASY ON THE MOMMA AND POPPA
DINOSAURS, IF YOU GET MY DRIFT.

JUST AS GOLDILOCKS WAS
DECIDING WHICH BED WOULD
MOST MEET HER NEEDS,
THE THREE DINOSAURS
RETURNED HOME!

AND STEPPED ON HER.

"DID YOU HEAR SOMETHING?"
ASKED POPPA DINOSAUR.

"NOPE," REPLIED
MOMMA DINOSAUR.

"THAT MEL GIBSON MAY BE A
NUTCASE, BUT HE MAKES A
DARN GOOD ACTION STAR,"
ADDED BABY DINOSAUR.

AND SO, THEY SAT DOWN IN THE
KITCHEN AND ENJOYED THEIR
PAELLA.

THE END.

QUESTIONS FOR THE READER:

Multiple choice:

Goldilocks is kind of a b*tch, isn't she?
a. Y*s
b. Y*u d*n't h*ve to t*ll m* TH*T tw*ce
c. Y*u h*artl*ss bastard
d. I'm a dancer

Dinosaurs have been extinct since:
a. Tuesday
b. Dude...
c. I'm a dancer
d. This is, like, a trick question, right?

Movies are cool.
a. Uh, that's not a question
b. Cool, like me
c. I'm a dancer

Essay question:

Obviously, the War casts a long shadow over this work. What is the author telling us about ourselves? Who are we? What is our address? Where did we leave our keys?

Extra Credit:

Mel Gibson. What's up with that?

13. STAMPS, PORTRAITS, & CARTOONS

The great *New Yorker* cartoonist and artist Saul Steinberg has been a hero since I first encountered his work while at NYU. Along with Ronald Searle and Jean-Jacques Sempé, Steinberg's angular approach and light, improvisational-looking line took my breath away. Inspiration begat emulation, and my drawing style aped his work, particularly in college.

One thing that was unique to Steinberg was the way he incorporated stamps and labels into his work, something I'd never done before.

As my book projects multiplied, I needed to find a way to organize my work. So I visited an office supply store and bought a bunch of stamps and stamp pads in order to date and label all of my original drawings and sketches.

Turns out, stamping a finished drawing is really fun! It's like a little reward after a bit of work. In fact, the stamping was so fun, before I knew it, I got carried away....

"I always enjoy receiving Mo's annual sketchbook. They're creative, witty, funny, and slightly nutty."
—Kadir Nelson, award-winning author and illustrator

88888
8888
8888
8888
8888
8888
8888

7777777
7777
7777
7777
7777
7777
7777
7777

7777777
LLLLLL
LLLLLL
LLLLLL
LLLLLL
LLLLLL
LLLLL

333333

section 1: stamps

333333

333333

333333

333333

333333

333333

333333

111111
111111
111111

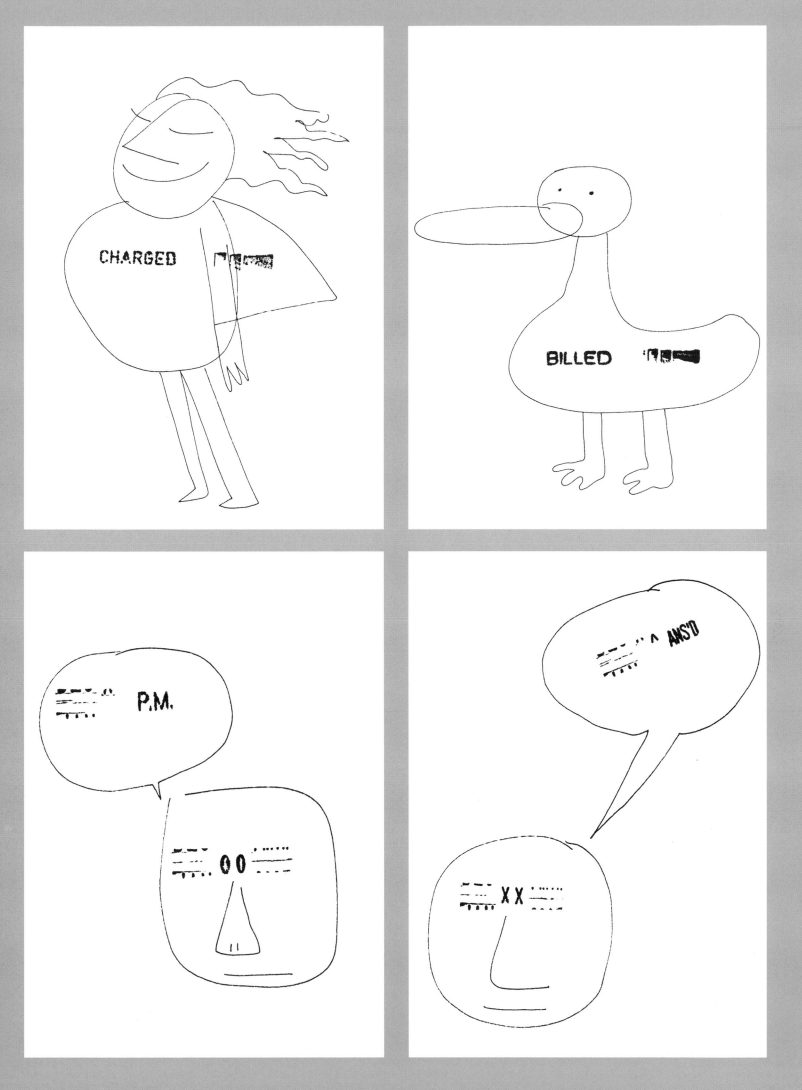

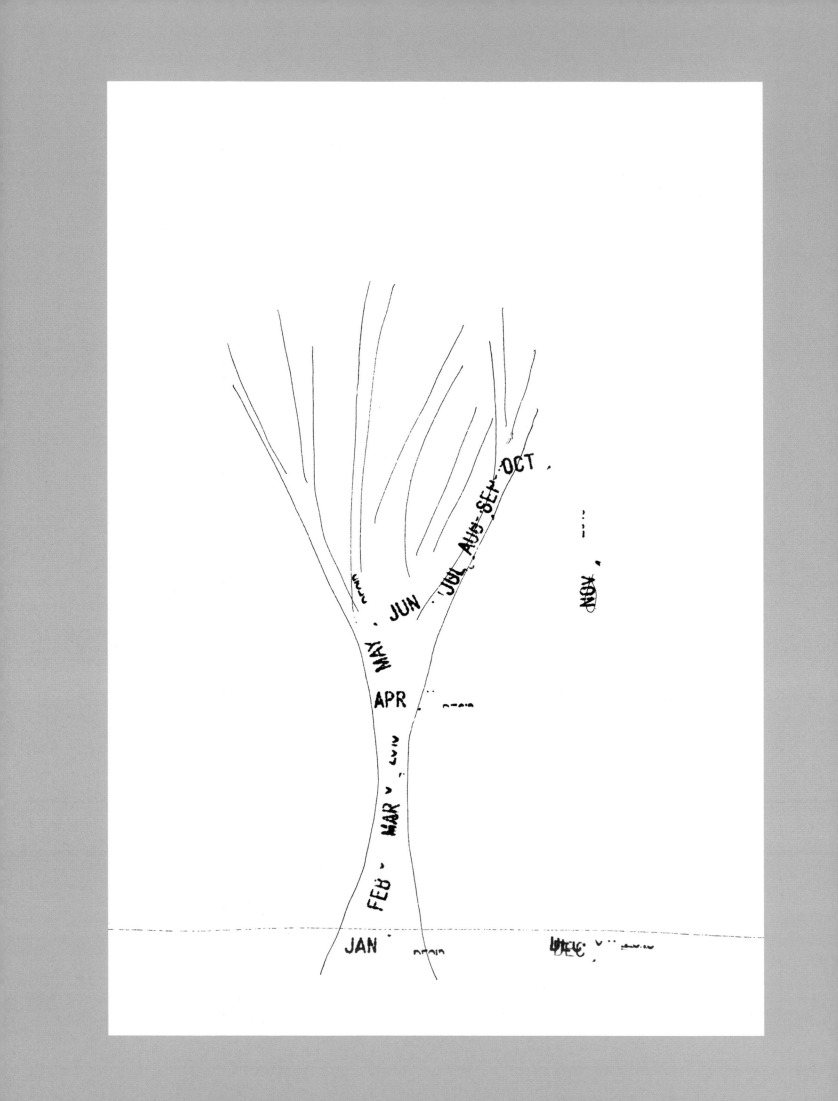

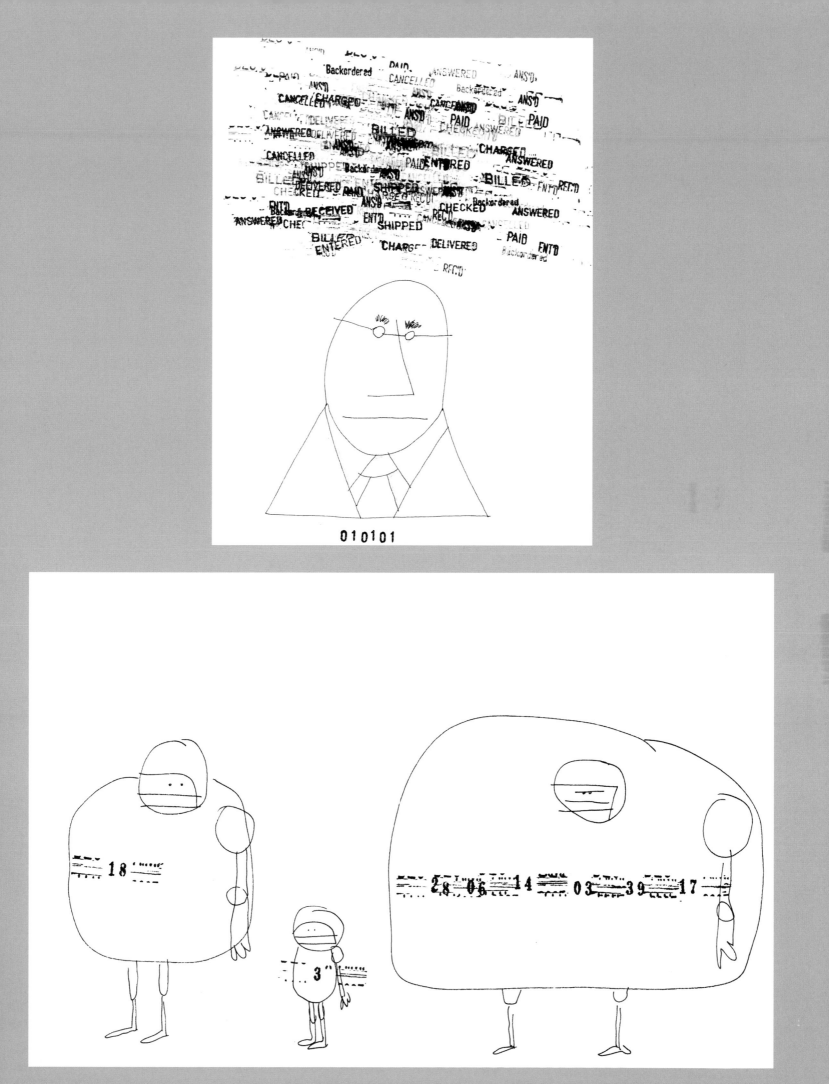

OCT 26 2005

PORTRAITS

THE FOLLOWING IMAGES WERE DOODLED BY THE UN-KNOWN LATE-19TH CENTURY CARTOONIST ENOCH VON HUBBARDPINES, WHO PURPORTED TO HAVE TOURED THE WEST IN THE YEARS FOLLOWING THE CIVIL WAR. WHILE SOME MAY COMMENT ON THE STIFF FORMALITY OF THE CARTOONS, ONE MUST REMEMBER THAT SKETCHING EQUIPMENT WAS MORE CUMBERSOME IN THOSE DAYS. VON HUBBARDPINES LUGGED HIS HEAVY CARTOONING APPARATUS OVER THOUSANDS OF MILES TO DOCUMENT HIS SUBJECTS. HIS CARTOONS WERE IGNORED FOR MANY SCORES OF YEARS, DUE PRIMARILY TO THEIR UNREMARKABLE NATURE, AND ARE PRESENTED IN THE SPIRIT OF HAVING RUN OUT OF MORE AMUSING IDEAS. —EDITOR

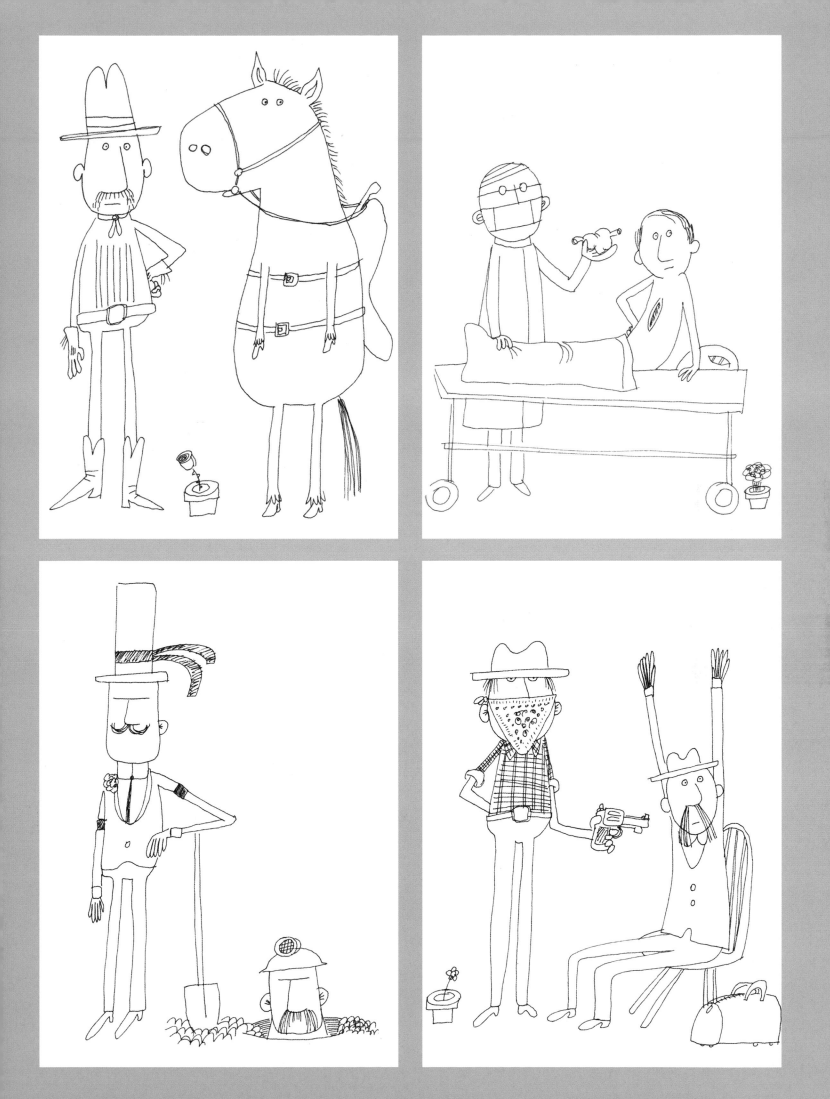

Nature abhors a vacuum.

Superman with a Van

"C'mon, snake eyes!"

What your mother would really do if she got a nickel every time you screwed up.

"'History is written by the winners,' my ass!"

"He can forgive, but he can't forget."

"I think I slept funny...."

"This next song had a lot of special meaning to me when I wrote it, but now I just hate it."

Squid Vicious

14. MONSTERS IN UNDERPANTS

My daughter and I could often be found on the hallway floor drawing together on big rolls of paper when this volume was made. Monsters are always fun to draw, and underpants are about the funniest thing in the universe, so that year, we started drawing a steady stream of Monsters in Underpants.

We were also spending more time in the country on the weekends and had amassed quite an eclectic collection of field guides. Marrying the two felt natural.

Mr. Willems'

ESSENTIAL REFERENCE
GUIDE TO:

MONSTERS
IN
UNDERPANTS

(ABRIDGED & INCOMPLETE)

a mo willems sketchbook
volume 14

NOTICE:
THIS ESSENTIAL GUIDE TO
MONSTERS IN UNDERPANTS
WAS RESEARCHED AT
CONSIDERABLE RISK TO
Mr. Willems AND HIS TEAM.
WHILE THEY MAY NOT BE
PROFESSIONALS, THEY ARE
PRETTY SERIOUS AMATEURS,
SO THERE.

EVERY EFFORT WAS MADE TO
BE AS ACCURATE AS POSSIBLE,
BUT WHEN YOU'RE FACE-TO-FACE
WITH A MONSTER IN ITCHY
TIGHTY-WHITEYS, YOU MIGHT
JUST FUDGE A DETAIL OR TWO
IN THE INTEREST OF TIME.

WARNING:
SEARCH FOR MONSTERS
IN UNDERPANTS
AT YOUR OWN RISK.

A MONSTER IN UNDERPANTS IS,
IN ALL PROBABILITY, LOOKING
FOR HIS/HER PANTS,
AND THEREFORE VERY
IRRITABLE.*

*MONSTER + IRRITABLE = NO GOOD.

Mr. Willems AND HIS TEAM
TAKE NO RESPONSIBILITY FOR
THEIR ACTIONS, SO YOU CAN
HARDLY EXPECT THEM TO TAKE
RESPONSIBILITY FOR YOURS.

ENJOY.

NAME: Raymond
SIZE: BIGGER THAN HE LOOKS
UNDERPANTS: TIGHTY - WHITEYS (TW's)
REMARKS: SAD/ EASY TO LAFF AT

NAME: SIMON
SIZE: 3 FEET (BUT THEY'RE BIG FEET)
UNDERPANTS: BOXERS, SILK
REMARKS: SKITTISH

NAME: UNKNOWN
SIZE: LEGS ABOVE THE REST
UNDERPANTS: TW'S
REMARKS: EWWWW....

NAME: LOUISE
SIZE: 4XL
UNDERPANTS: ITCHY
REMARKS: GOOD PUPPETEER

NAME: "MMFoHLP"

SIZE: ?

UNDERPANTS: TOO TIGHT

REMARKS: WOBBLY

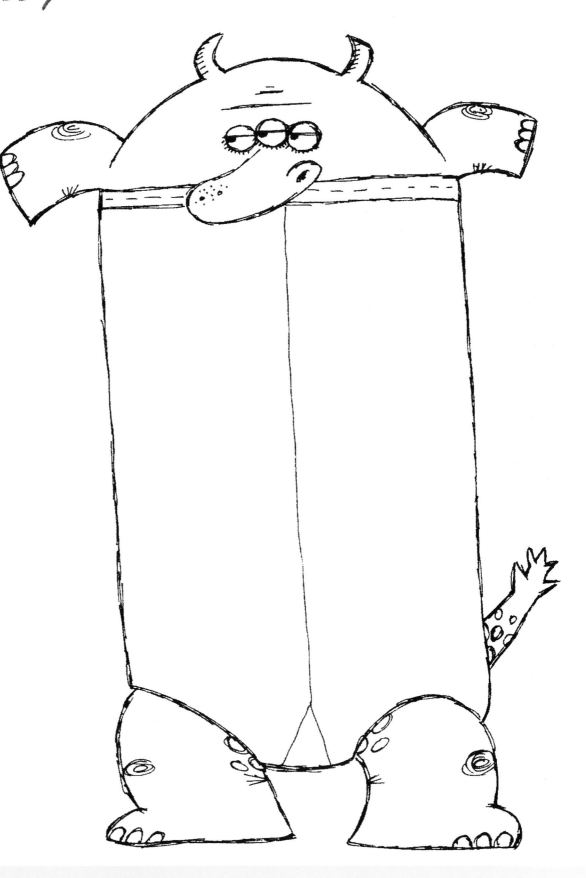

NAME: BERTHA

SIZE: HUGE!

UNDERPANTS: OH, SO SILKY

REMARKS: FLOPPY

NAME: *Didn't stick around to find out*

SIZE: *See above*

UNDERPANTS: *See above*

REMARKS: *See above*

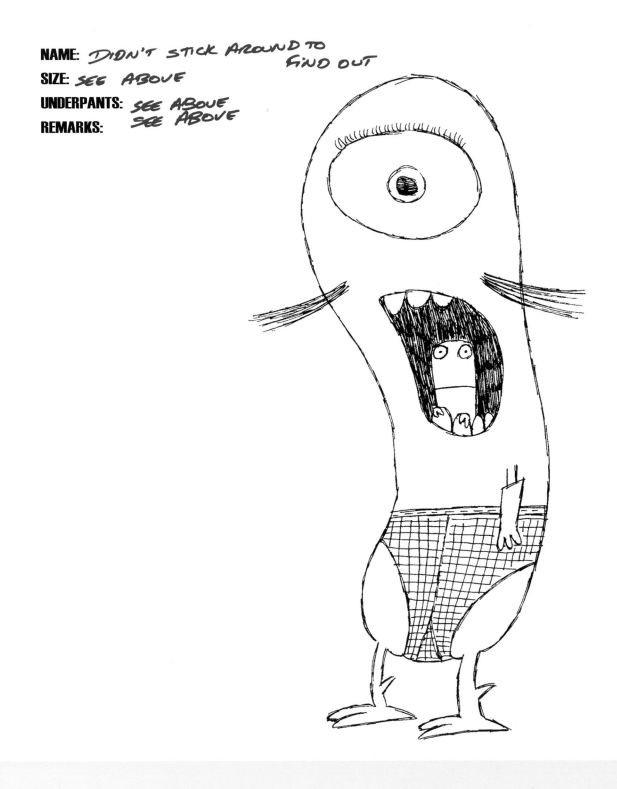

NAME: MALROD

SIZE: ∞

UNDERPANTS: EXPENSIVE!

REMARKS:

SAW HUGE
BUTTERFLY
LATER IN
DAY.

NAME: Billy
SIZE: 2½ FT.
UNDERPANTS: SNUG TW's
REMARKS: EXCEEDINGLY LETHAL!!!

LOOK FOR THESE OTHER

Mr. Willems'

ESSENTIAL REFERENCE

GUIDES TO:

—PUPPIES WITH REALLY SHARP TEETH

—SURLY RESTAURANT STAFF

—FRENCH WOMEN

—VARIOUS YOGURT DISHES

—HUNGRY, DISORIENTED BOBCATS

WHEN YOU FIND THEM,

LET US KNOW.

BE AFRAID.

BE VERY AFRAID.

OR DON'T.
LIKE WE CARE.

THANK YOU FOR STOPPING. BYE.

15. A BEAR REMEMBERS . . .

Characters often emerge after doodling them for a while without any clear direction or rationale. For example, I'd spent years absentmindedly sketching elephants before creating the Elephant and Piggie books. (After I did, elephants disappeared from my doodle repertoire.) Similarly, a giant batch of alligator sketches predated Alligator from *Hooray for Amanda and Her Alligator!*

Stuffed, yet living, teddy bears were also a recurring doodle theme for a while. I thought the idea of a bear aging with its owner was funny, but also a little creepy. And it was the creepiness that kept me from being able to come up with a workable picture book for my bear.

Still, I love the weirdness of this story, and I had fun telling a wordless story (a challenge I'd still like to attempt with a picture book). It's not for kids, but it's fun.

a bear remembers...

a mo willems sketchbook

volume #15

beginnings...

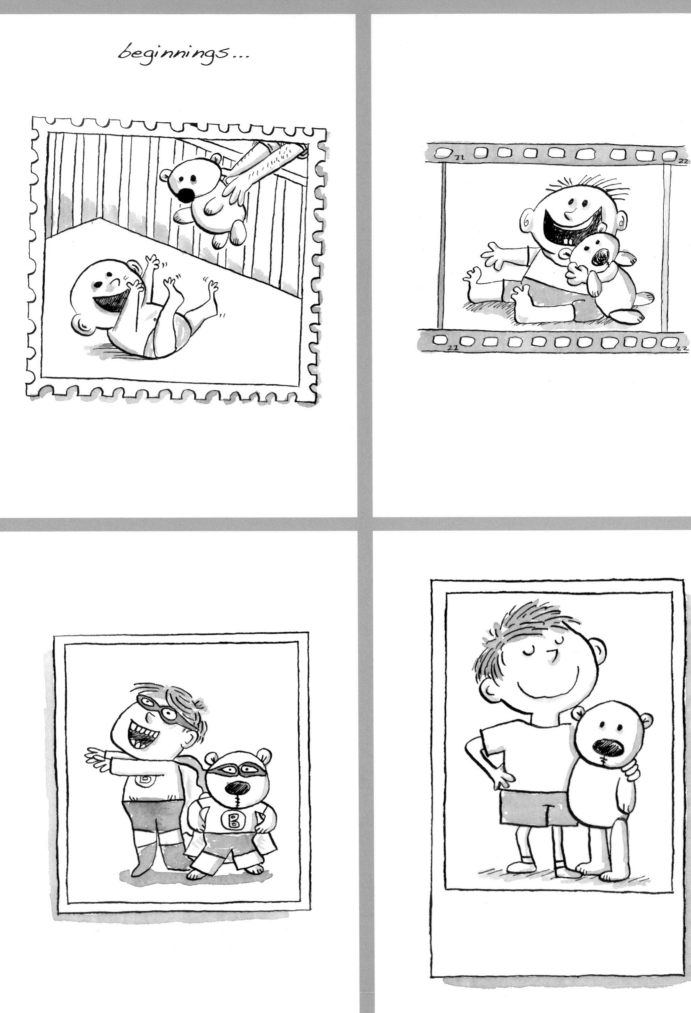

the incident...

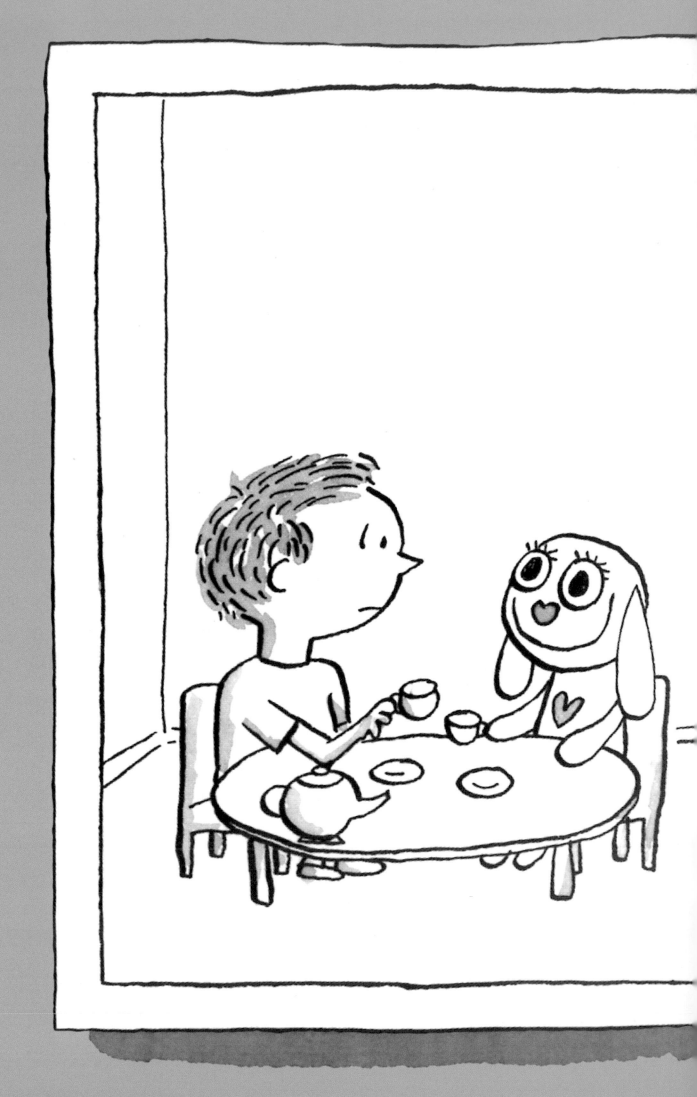

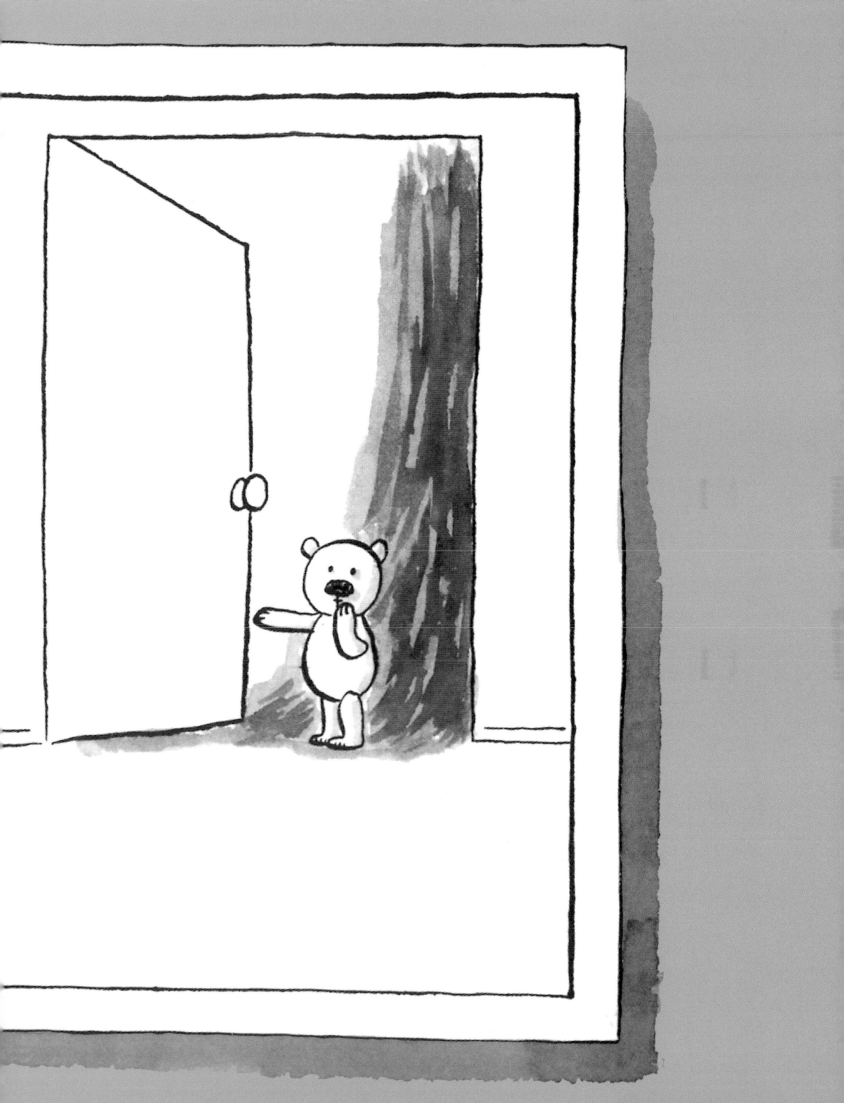

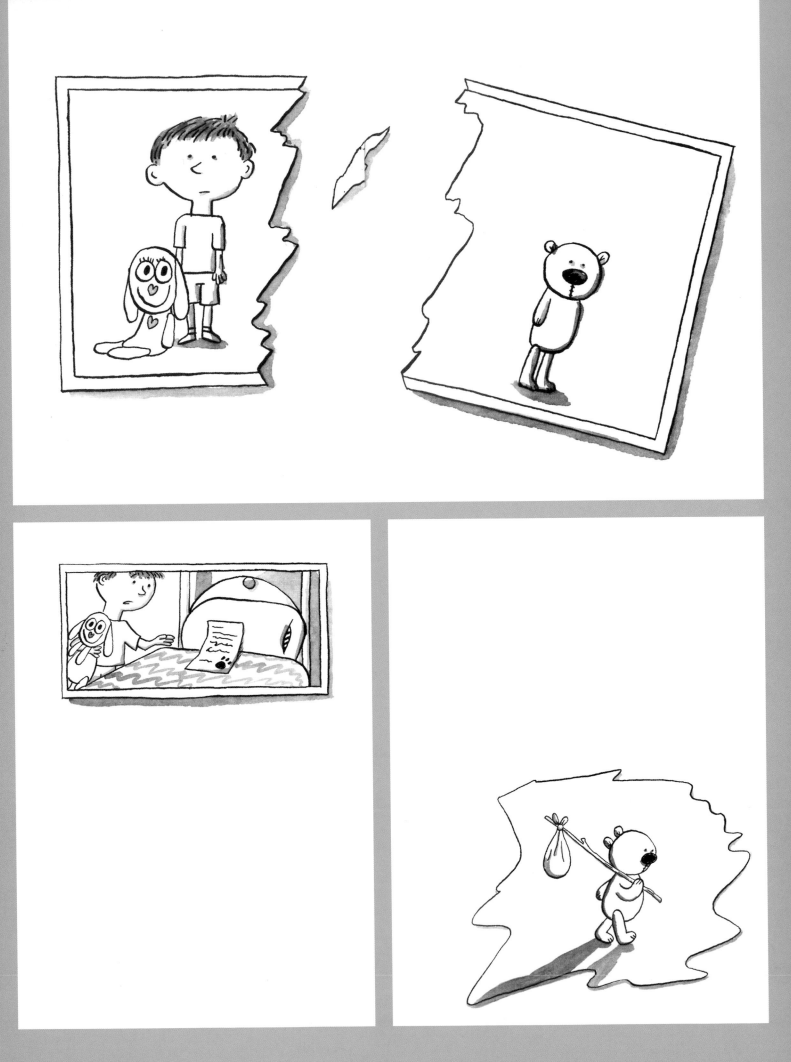

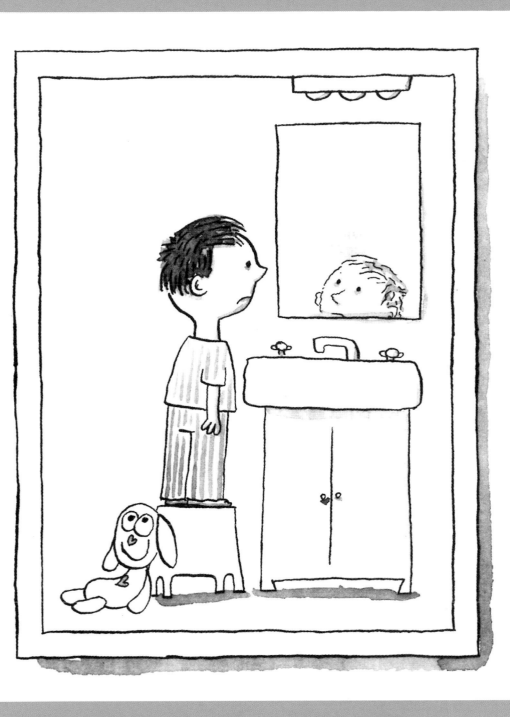

a chance encounter...

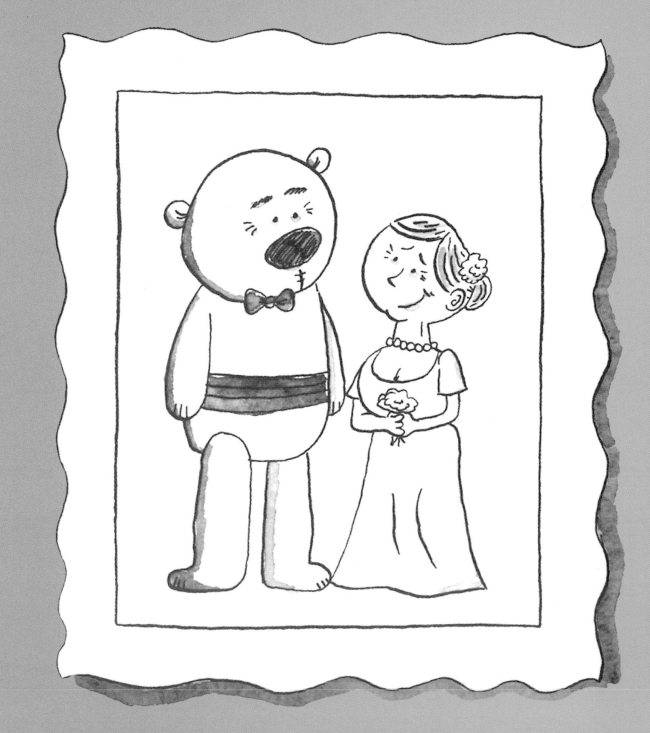

a bear remembers...

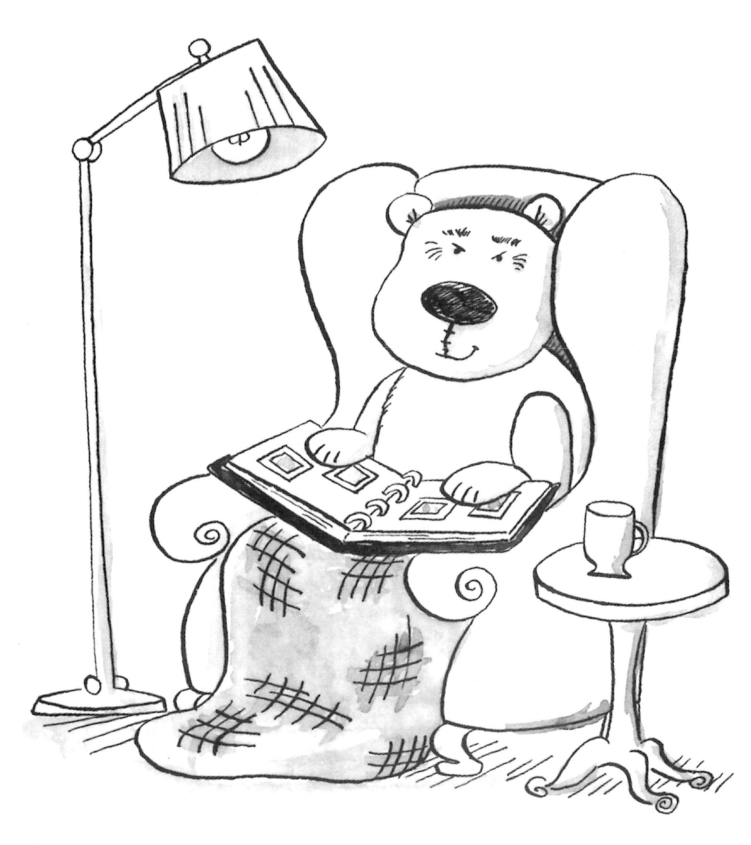

16. THE DEVIL YOU KNOW

I returned to the gag cartoon format from the first years of making sketchbooks because I discovered that, unlike in the previous years, I already had a bunch of gags that had accumulated in my flat files.

This was partially because I'd managed to talk NPR's *All Things Considered* into letting me become their "Radio Cartoonist." The idea was that I'd describe an illustration on air, and let the listeners come up with various caption ideas before I told them what I'd had in mind.

While I loved doing them, radio cartooning turned out not to be a genre for a reason, even after I promised to do the Sunday ones in color.

The Devil You Know

And Other Doodles.

**a mo willems sketchbook
vol. 16**

"If a stranger walked up to me on the street and told me to
name my favorite cartoonist, I would explain that I don't talk
to strangers. But I would be secretly thinking, 'Mo Willems.'"
—Lemony Snicket

Some of the drawings in this sketchbook originated as "Radio Cartoons" for NPR's *All Things Considered.*

Others didn't.

"*Actually, I'm more of a cat person.*"

"*Dear Catherine, wish you were here...*"

"*This place is AWESOME. Next week they're giving us cell phones!*"

Monuments of Industry

Sculpted Bust of
Corporate Leadership

The Salt Shaker of
Middle Management

Bowling Trophy of
the Unknown Worker

No Fair.

"Everyone else around here treats me like a baby!"

Six Foot Tiger.

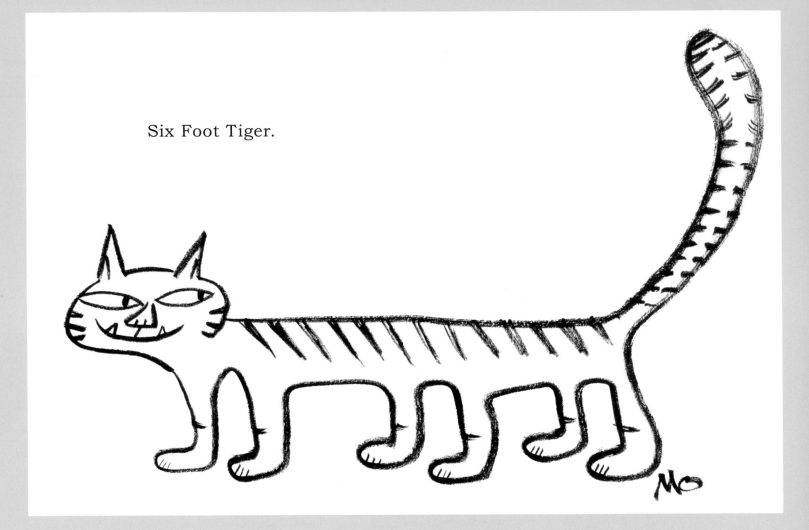

ELEPHANT AND PIGGIE!

"Arrr! He be **twice** the man I could ever be!"

Way Too Open Mic Nite

"The 'Neighs' have it."

Family Style Restaurant.

"Shirley, you jest!"

17. FLOAT

Float is the sketchbook that has gotten the most passionate and personal responses from my limited pool of readers. After reading it, friends have bemoaned their childhood, parents have resolved to allow their children greater freedom, and some pals have just cried.

I'd been drawing the sad little schoolboy for over a year. I woke up one morning itching to get to the drawing table but with no idea in my head of what to do there. Still, by the end of the day, all of the drawings for this edition were complete. In retrospect, I know the story came from somewhere deep inside.

When I counted up the drawings, they were, almost magically, the exact number I needed for the pages in the booklet.

FLOAT

a mo willems sketchbook
volume seventeen

"Everything you have ever wondered about is in this book, except, of course, anything you need to know. It is inspired, hilarious, and drawn with the skill and insight that only someone who can't draw can achieve. I wish I couldn't draw the way Mo can't draw."
—Norton Juster, author of *The Phantom Tollbooth*

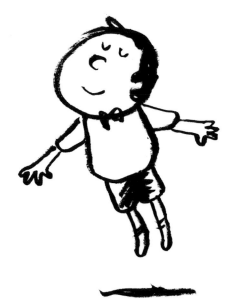

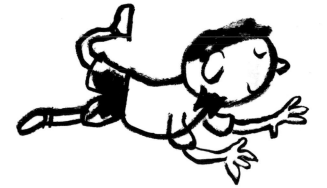

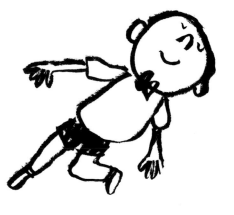

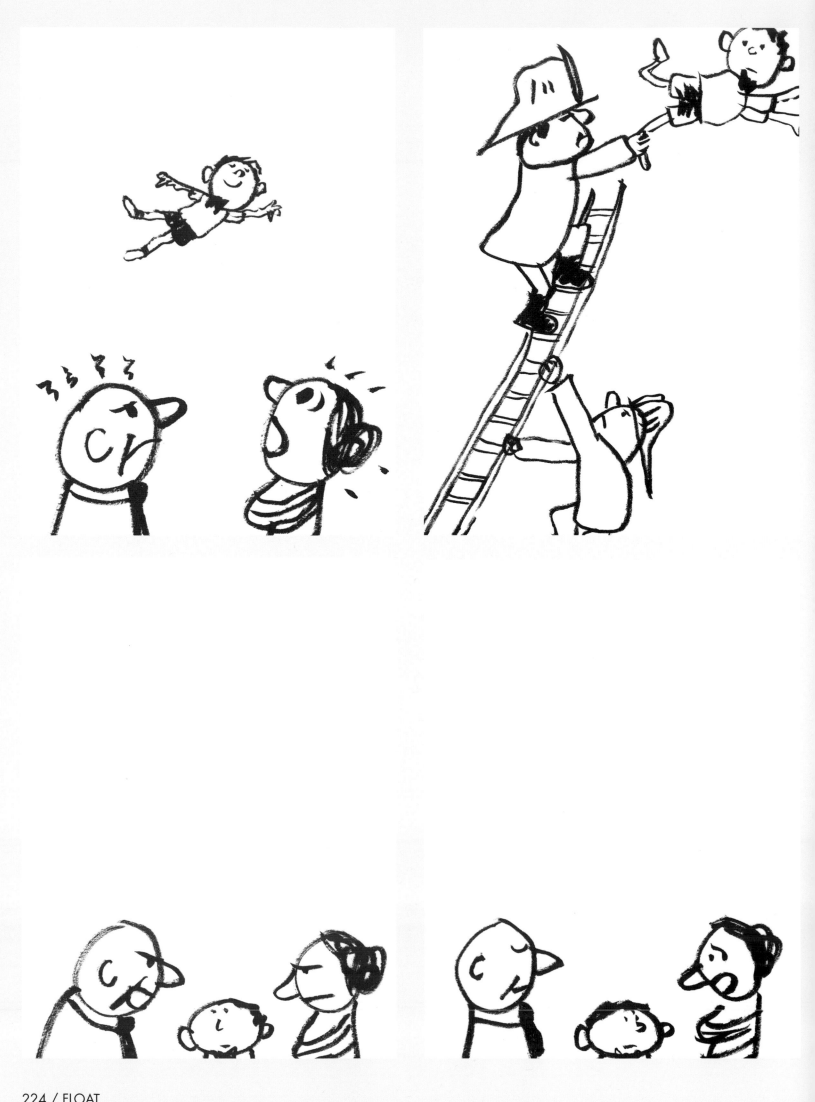

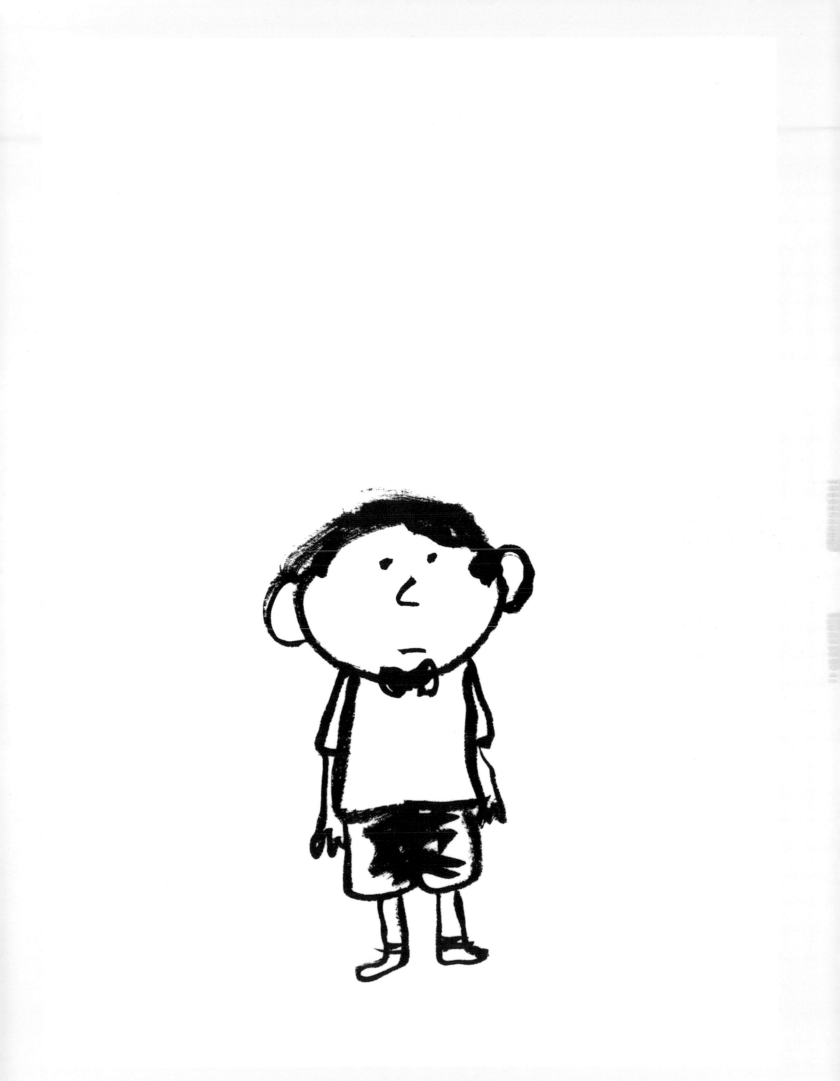

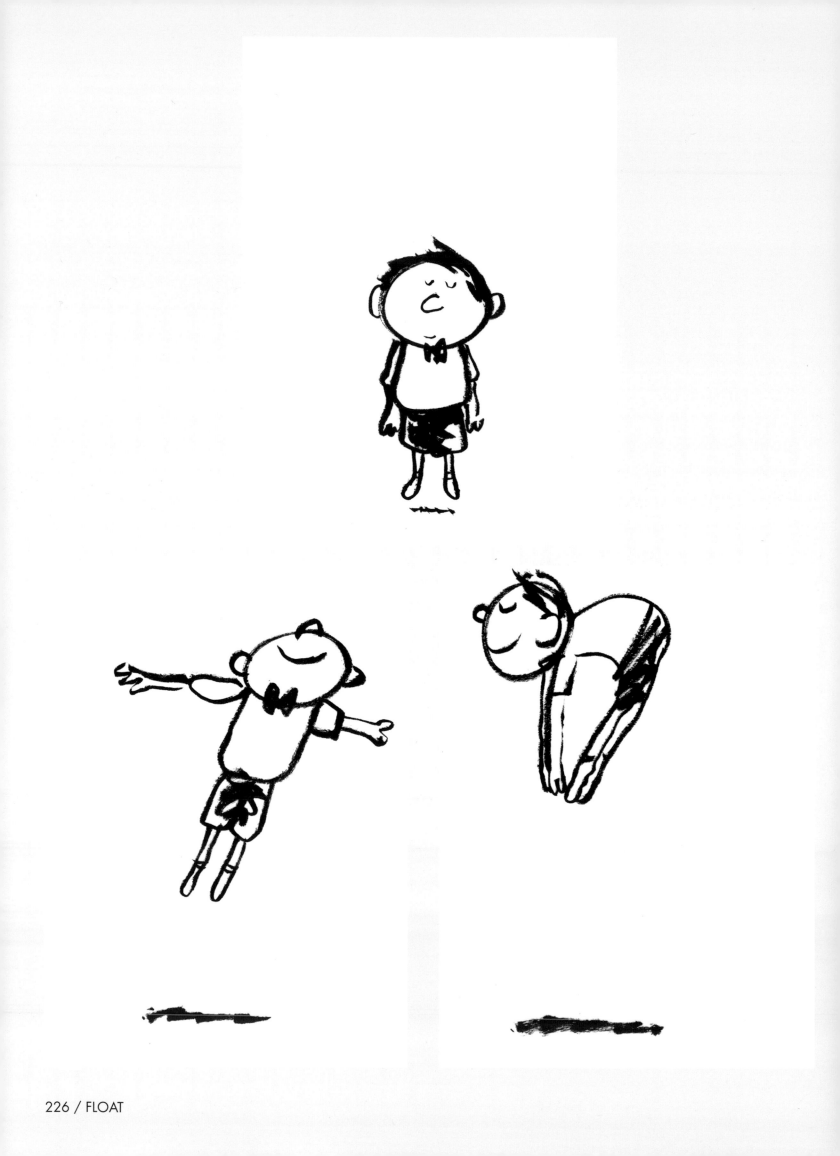

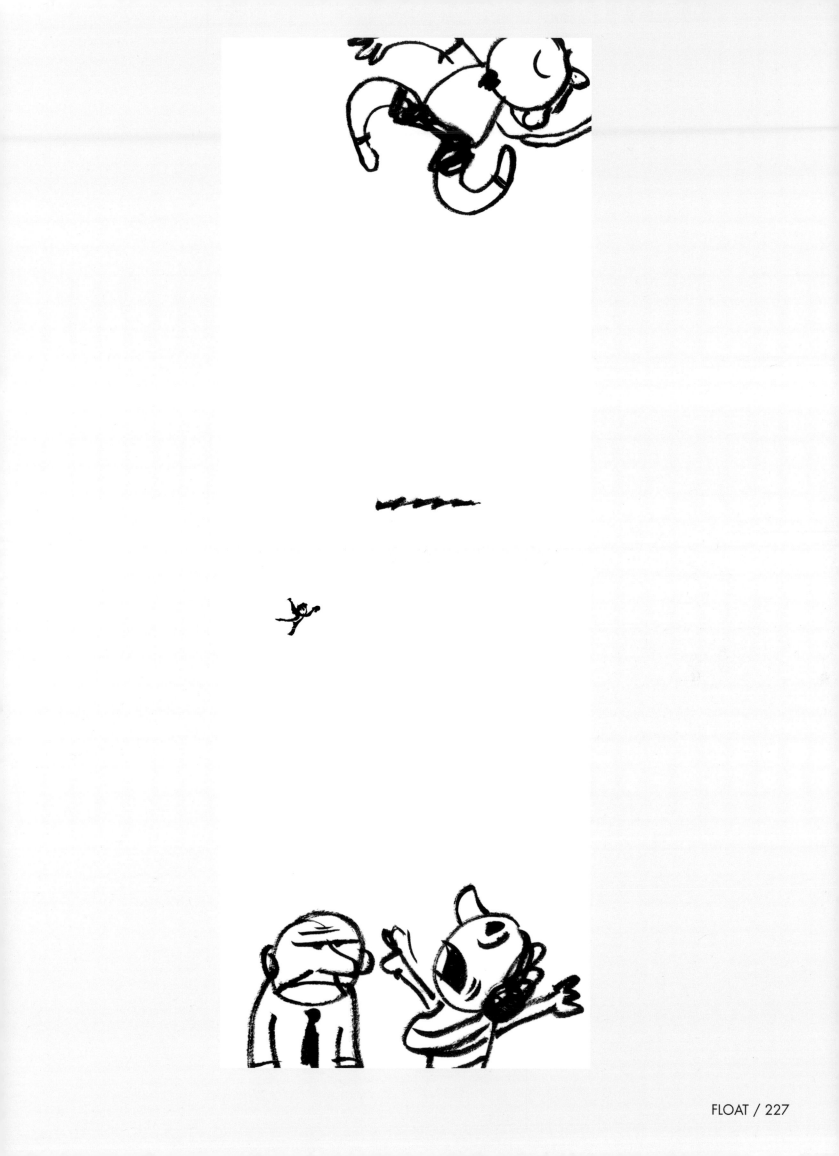

[end]

18. THE RED TRUCK

When making picture books, I'm lucky to be able to print any and every color imaginable. But freedom like that makes it easy to take color for granted.

For *The Red Truck*, which became my third wordless story sketchbook, I was interested in what could be done with just two colors: black and red.

Again, the dog was someone I'd spent the previous months doodling; but this time I planned out the story in a more methodical way than in the previous year.

the red truck

a
mo willems
sketchbook

volume 18

"Mo Willems' work fills me with delight, wonder, and jealousy.
Why is he so FUNNY?"
—Julianne Moore, children's book author and actor

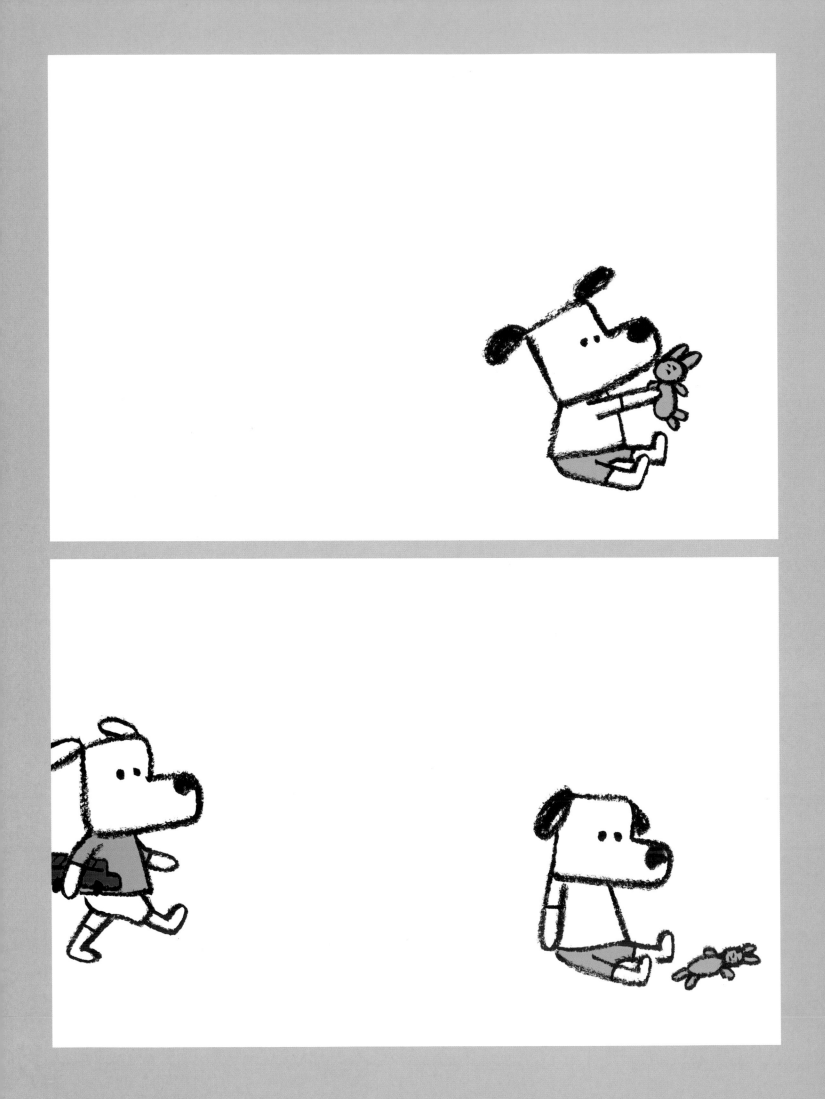

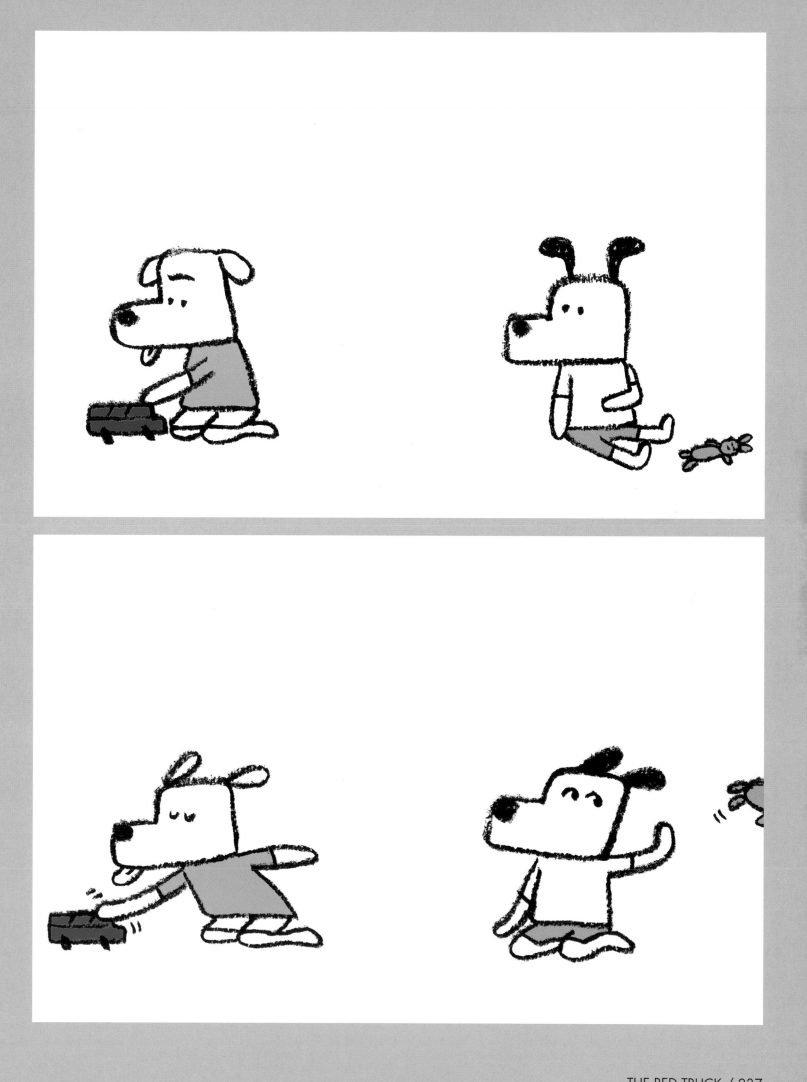

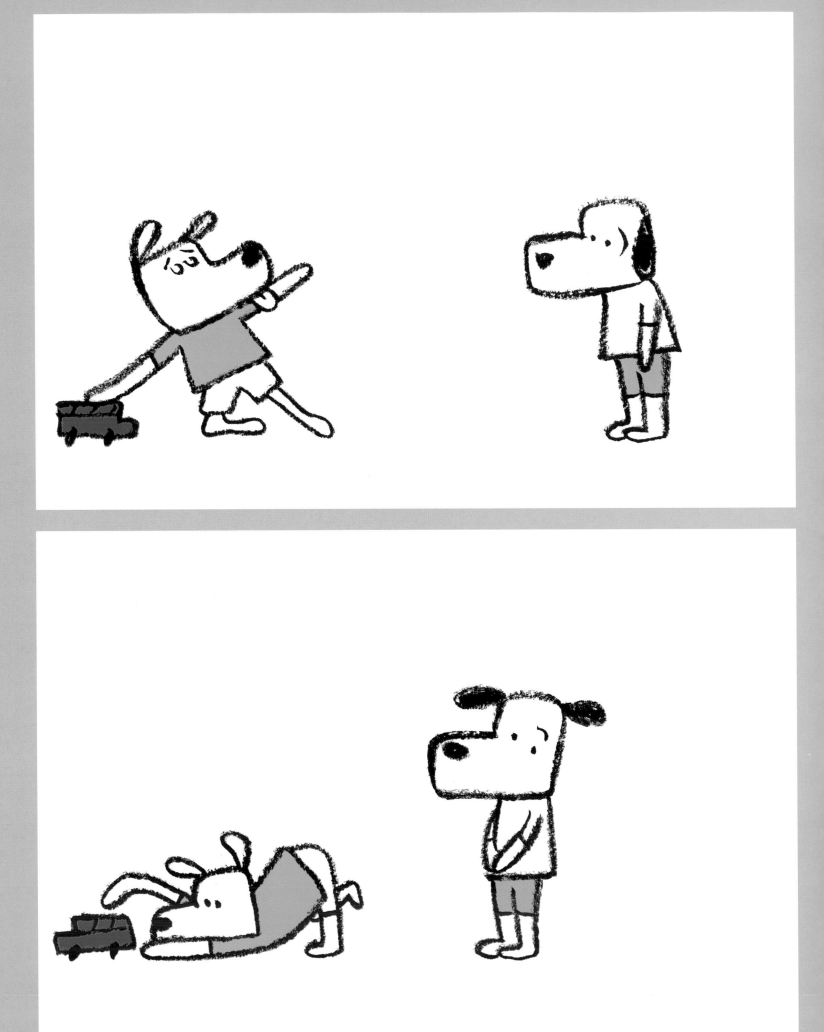

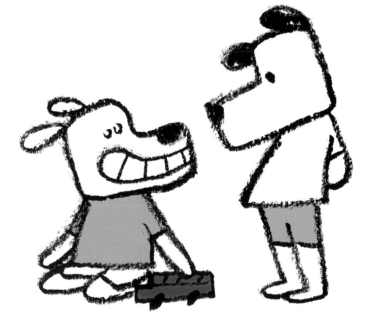

end

19. OLIVE HUE SHOW MUTTS

One of the greatest joys in my career has been the ability to make the Elephant and Piggie easy readers. They are so fun to draw, and I'm constantly amazed and pleased that my publisher wants more of the stories.

Back at *Sesame Street*, the writers were required to attend child-development seminars, some of which involved learning about how kids learn to read, a topic that really interested me. Later, it was fascinating watching my daughter decode shapes into letters, then letters into words, followed by words into story.

I think we often forget how hard and slow-going learning to read can be when you're at its cusp, and I wondered what it would be like to go back to that point.

The result is this "hard reader," a drunken diatribe of words that merely sound like what they mean. This story almost requires that you read it aloud, much like children must do when reading their first books independently. I hope you find it funny and that it gives you empathy for all of those young readers struggling out there.

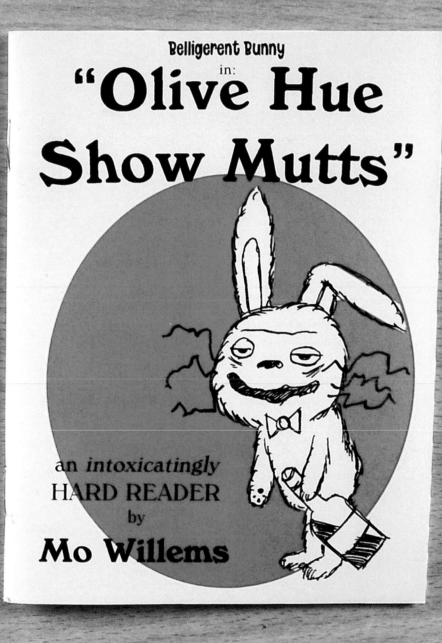

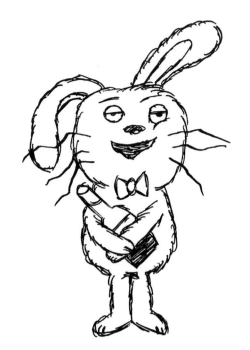

"Olive hue."

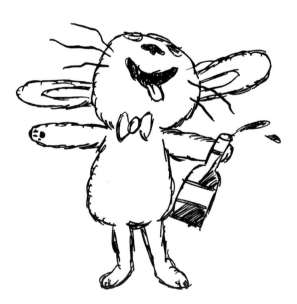

"Olive hue show mutts!"

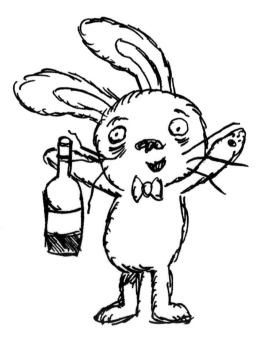

"Show berry mutts."

"Yore show spa shell."

"End pert tea."

"Flower bout hay kitch?"

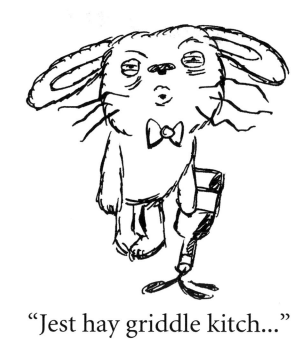

"Jest hay griddle kitch..."

"Police?"

"Pert tea police?"

"EYE WAND
HAY KITCH!"

"Washer madder?"

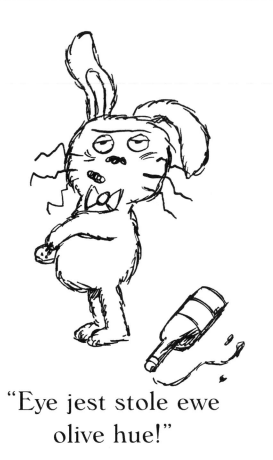

"Eye jest stole ewe
olive hue!"

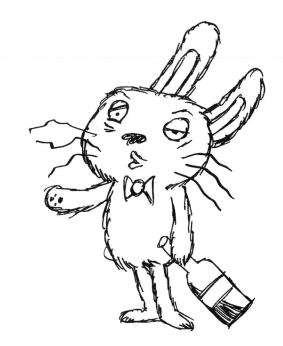

"Aisle kitch hue beck."

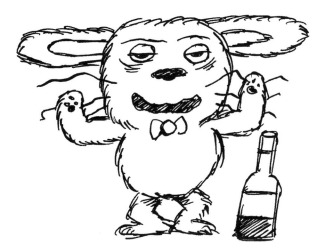

"Oaky, oaky, oaky, oaky,
oaky, oaky. Eye git itch."

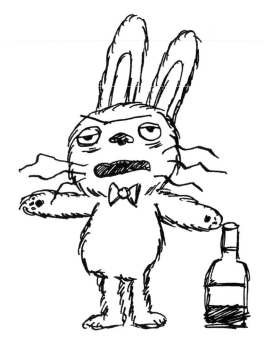

"Know kitchen farmy."

"Dishes show shad."

"SMUT DOSE SUM WON HALF TAH DEW TWO GIT HAY GRIDDLE KITCHEN AGROUND SHEAR!?!"

"Eye jest gaunt
sum shoving."

"Itch chat hatch king
two mutts?"

"Whelp, forge edit!"

"Eye dude knot
kneed ewe!"

"Aisle fined sum
won elves two kitch!"

"Hue shrink eye kant?"

"Eye canned two!"

"Yule she."

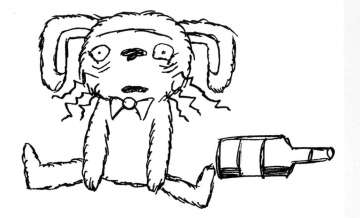

"Lyme sheepy…"

"Show sheepy…"

"Lyme show ha loan."

DESCEND.

"Zzzzzzzshshshsttffppfft…"

20. COMMUTING PENGUINS, AND OTHER DOODLES

As you can tell by now, I am an advocate for doodling. Not just by kids, but by everyone. There is no such thing as a "wrong" drawing. Sketching on the page isn't broccoli; it can be, and should be, fun. Sure, there comes a day in everyone's life when they realize they won't become an artist or professional basketball player when they grow up. But, by and large, people keep playing basketball and stop drawing. It's a shame.

If you are averse to doodling, don't come to dinner at the Willems household. Our dining room walls above the wainscoting are made of chalkboard, and the tablecloth comes from an immense roll of butcher paper. Dinner is about the food, the conversation, and the drawing. Part of the fun is that we all have our own style. My daughter draws realistically or in a manga style. My wife creates elaborate abstract patterns or forms to experiment with for her pottery. And I, at least lately, have been drawing commuting penguins. This year's sketchbook is a collection of doodles drawn on that butcher paper including those penguins, some of whom may or may not appear in a future picture book.

I don't know yet, and I like it that way.

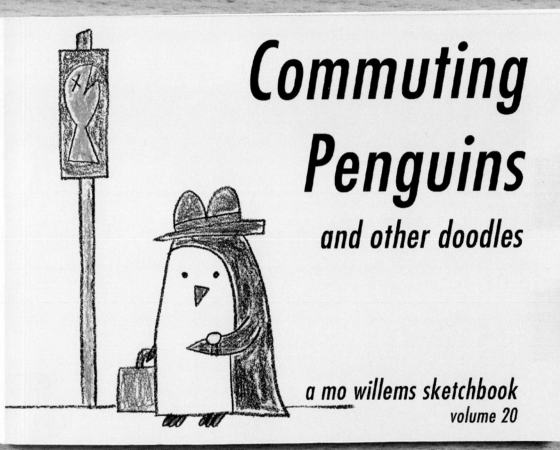

Commuting Penguins

and other doodles

a mo willems sketchbook
volume 20

"Hmmm…what nice things can I say about Mo? Well, he's married to a friend of mine from college. She's great. Also, their daughter Trixie is incredible. Oh, and Mo is one of the funniest, most inventive, and intelligent creators of picture books working today. How's that?"

—Brian Selznick, author of *The Invention of Hugo Cabret*

Two years ago my wife gave me a large roll of butcher paper & big box of crayons for my birthday. Since then, the family has spent nearly every night doodling after dinner.

(mostly commuting penguins)

It's fun!

This year's sketchbook is a compilation of those drawings, and others inspired by just doodling. Why not have a doodle dinner yourself?

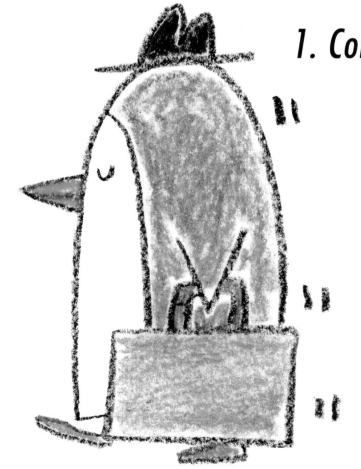

1. Commuting Penguins

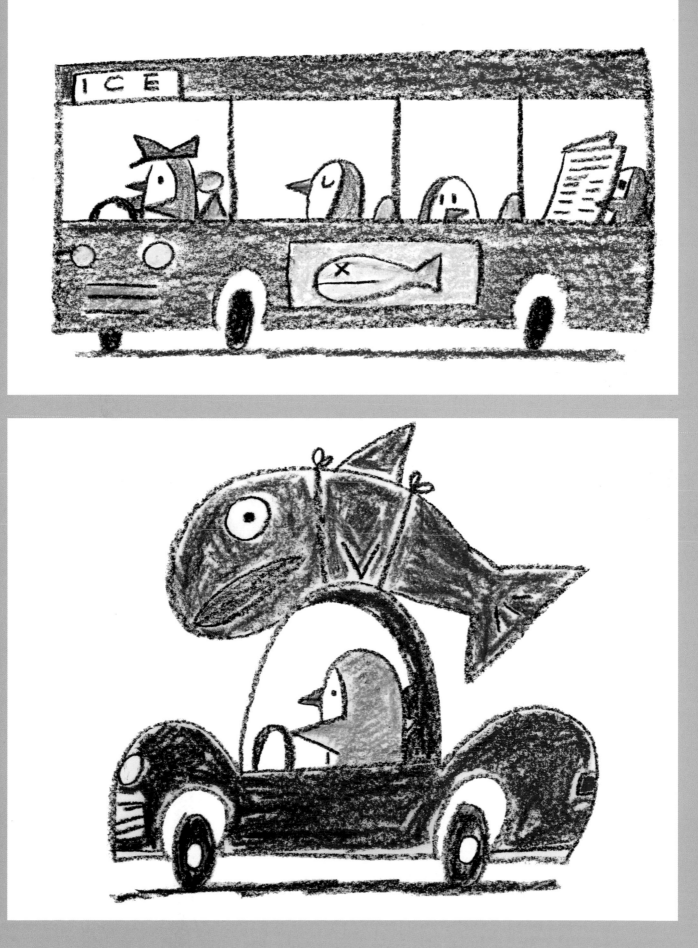

2. Not Commuting Penguins

3. Cul de Sac *Hijack*

This year a group of cartoonists were asked to take over Richard Thompson's excellent Cul de Sac comic strip while he took a hiatus to focus on physical therapy to battle Parkinson's disease.

As a longtime fan of the strip, I was honored to be included. My week playing with Richard's characters concludes this year's sketchbook.

(Thanks to Stacy Curtis for his lovely inking)

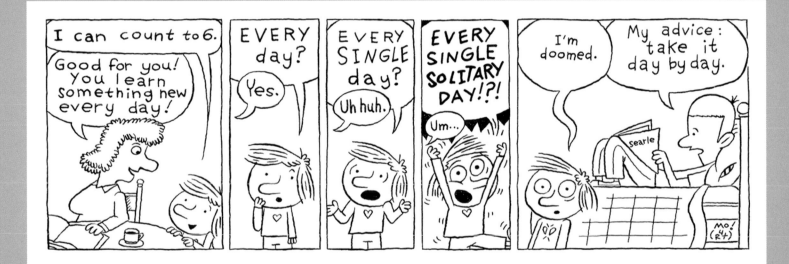

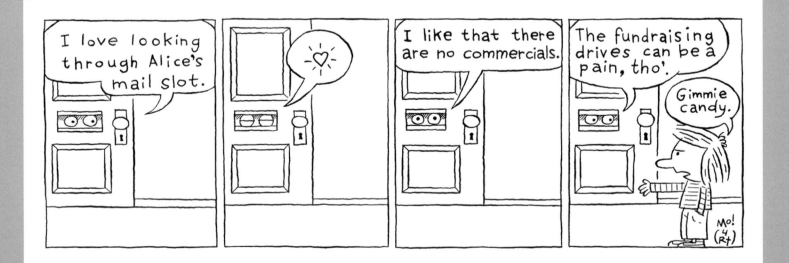

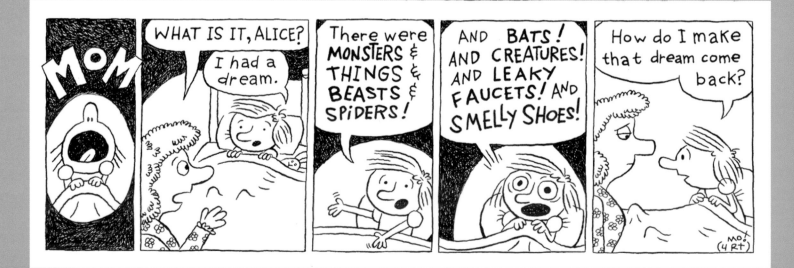

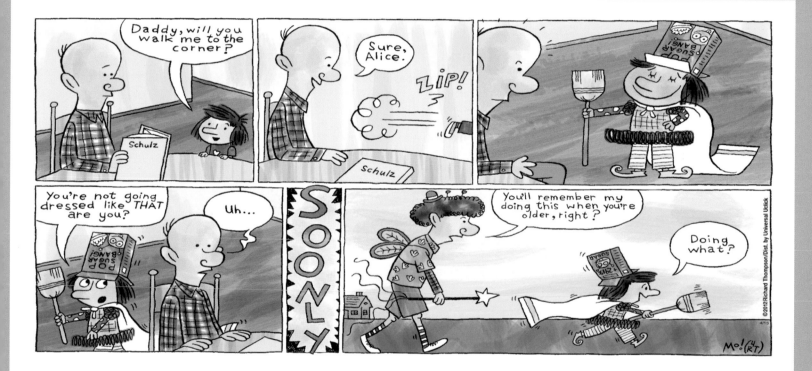

For information address Disney Editions, 125 West End Avenue, New York, New York 10023.

First Edition
3 5 7 9 10 8 6 4 2
FAC-029191-17342

Printed in Malaysia
ISBN 978-1-4231-4436-6

This book is set in Futura LT Pro, Helvetica Neue LT Pro/Monotype; Minion Pro/Fontspring

Reinforced binding

Visit www.mowillems.com, www.pigeonpresents.com, and www.disneybooks.com

ACKNOWLEDGMENTS

Thanks to Christian, Wendy, Tyler, Suzanne, Jeanne, and the entire Hyperion team for making this quixotic project a reality.

Also, to all of the pals who were forced to say nice things about me in this book. I am flattered and appreciative to each of you for your willingness to bend the truth.

Many thanks to Marcia, the agent who saw something in these sketchbooks that led her to believe I could make children's books, and to Alessandra, the editor who was determined to show that "unusual" is not pejorative.

But, the most thanks are reserved for my wife, Cher, and my daughter, Trixie, who every day help me remember to laugh.

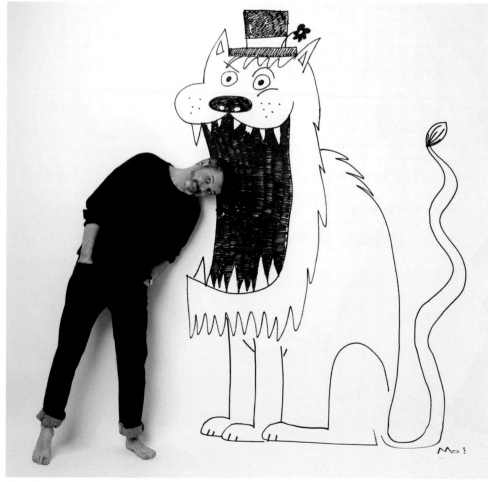

Marty Umans